The Isabella Stewart Gardner Museum

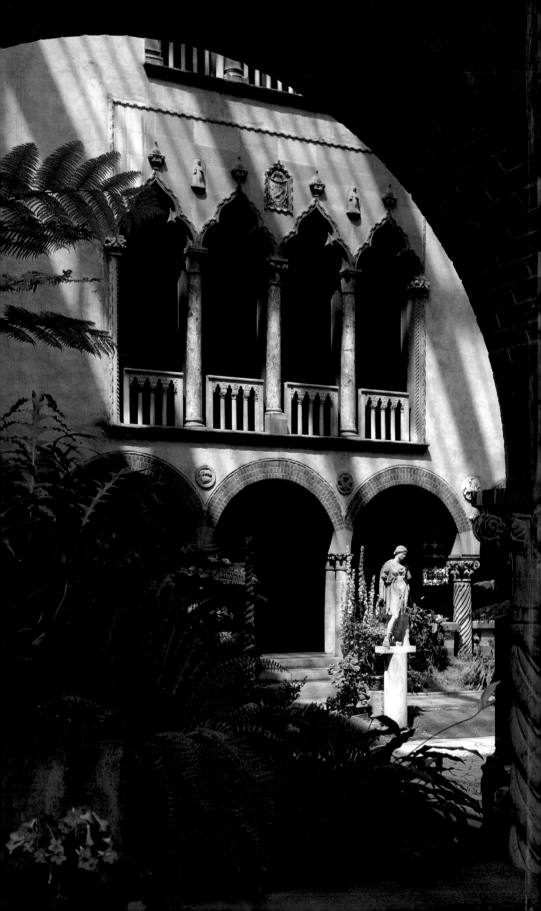

The Isabella Stewart Gardner Museum

A COMPANION GUIDE AND HISTORY

Hilliard T. Goldfarb

New photography by David Bohl

THE ISABELLA STEWART GARDNER MUSEUM, BOSTON

YALE UNIVERSITY PRESS, NEW HAVEN & LONDON

Designed by Nancy Ovedovitz. Set in Sabon type by
The Composing Room of Michigan, Inc., Grand
Rapids, Michigan. Printed in Singapore by Imago
Productions.

Library of Congress Cataloging-in-Publication Data

Isabella Stewart Gardner Museum.
The Isabella Stewart Gardner Museum : a
companion guide and history / Hilliard T.
Goldfarb.
p. cm.
Includes index.
ISBN 0-300-06341-5 (acid-free paper)
1. Isabella Stewart Gardner Museum—Guide-
books. I. Goldfarb, Hilliard T. II. Title.
NA521.I7A84 1995
708.144′61—dc20 95-10912
 CIP

A catalogue record for this book is available from
the British Library.

The paper in this book meets the guidelines for
permanence and durability of the Committee on
Production Guidelines for Book Longevity of the
Council on Library Resources.

10 9 8 7 6 5 4 3

Frontispiece: View from the East Cloister, looking
west through the courtyard

Contents

In the past several years the Isabella Stewart Gardner Mu- *Preface*
seum has embarked on a major restoration of the museum
building and collection. At the same time we are restoring the intellectual
and artistic life so integral to the vitality of Fenway Court during its
founder's lifetime. It was then a major center for intellectual and artistic
exploration with artists, writers, musicians, composers, and choreogra-
phers patronized and presented by Isabella Stewart Gardner. Today it is
becoming that again.

As part of this scholarly and artistic restoration, the museum is recat-
aloguing the collection and writing new guides for the public. This book
takes you through the collection gallery by gallery, illuminating the art
and installations of each room.

A new gallery with changing exhibitions is also part of the renewal of
the Gardner Museum. Rotating exhibitions examine aspects of the per-
manent collection and feature new works by contemporary artists. Dur-
ing your tour of the collection you might even see an artist, poet, or
choreographer at work—the museum now hosts a series of artistic re-
sidencies during the year. The new gallery is located through the door-
way opposite the main staircase.

Isabella Stewart Gardner died on July 17, 1924, secure in the knowl-
edge that her collection would endure forever. Her will stipulated that
Fenway Court and the collection become a museum "for the education
and enjoyment of the public forever." She left an endowment to operate
the museum along with requirements that nothing in the galleries ever be
changed from their original installation and that no items in the collec-
tion ever be added or sold. Fenway Court was to remain her creation.

Whether that will should be challenged is often debated, but as we
approach the one-hundredth anniversary of the founding of the Gardner
Museum, its value as an exemplar of a Victorian woman's personal taste,
as a time capsule of an important moment in the cultural development
and history of the United States, outweighs all temptations to change. As
that era recedes further into the past we expect that this museum, pre-
served as a paradigm of a vital era and regenerated as a dynamic center of

contemporary artistic and intellectual activity will become even more valuable and enduring.

We hope you will have many occasions to return to the Gardner Museum and to use this guide. And we hope you will fall in love, as we have, with the museum and its unique creation. It is one of the few museums in the world that speaks to nearly all the senses through art, flowers, music, and architecture. It will reach you in unsuspecting ways.

We thank Hilliard Goldfarb, Chief Curator, for writing the book, and Patrick McMahon, Registrar and Assistant to the Curator, for coordinating and editing the photography and preparing the manuscript. Thanks also to the museum's conservation department for its work in facilitating the photography: Barbara Mangum, Chief Conservator; Valentine Talland, Associate Conservator in Charge of Objects; Ada Logan, Associate Conservator in Charge of Textiles; Gisèle Haven, Upholsterer and Seamstress; and Muffie Austin, Assistant Textiles Conservator. Thanks, too, to Museum Archivist Susan Sinclair. Our appreciation goes to photographer David Bohl, who spent many hours in the galleries creating the right images; to Jill Medvedow, Deputy Director for Programs and Curator of Contemporary Art, who oversaw the project; to Robert A. Radloff, Chairman of the Overseers, who started us on this endeavor; and, finally, at Yale University Press, to Judy Metro, Senior Editor, and Laura Jones Dooley, Assistant Managing Editor, who patiently guided the manuscript to publication.

Anne Hawley
Director

Isabella Stewart Gardner
and the Creation
of Fenway Court

Inscribed over the central portal of the Isabella Stewart Gardner Museum is a pithy summation of the founder's attitude toward her self-defined mission: "C'est mon plaisir." In the short space of a quarter-century Isabella Stewart Gardner amassed a collection of more than 2,500 objects dating from ancient Egypt to Matisse, including paintings, sculptures, drawings and prints, historic furniture, ceramics, glassware, books, and manuscripts, and she designed an environment at Fenway Court (her "palazzo" on the Fens) to house them. That environment fulfilled her ambition to enrich American cultural life through a benefaction unprecedented in the United States. In advance of such renowned collectors as J. P. Morgan, Henry Clay Frick, and Henry E. Huntington, Gardner established the idea in America of housing great art works in a palatial setting that had been created, as she bequeathed it in her will, as a museum "for the education and enjoyment of the public forever." Although Gardner's life was enriched by acquaintance with many of the greatest intellectual and artistic figures of the age, including Henry and William James, Henry Adams, Charles Eliot Norton, Julia Ward Howe, Dame Nellie Melba, Oliver Wendell Holmes, James McNeill Whistler, Bernard Berenson, and John Singer Sargent, as well as the many passing social celebrities of the times, the figures that evoked her most enduring passions were of another age. They included Dante, Giotto, Simone Martini, Fra Angelico, Titian, Raphael, Rubens, and Rembrandt.

Isabella Stewart was born in New York City on April 14, 1840, the daughter of David Stewart, who made a fortune in Irish linen and later mining investments, and Adelia Smith Stewart. She was the eldest of four children but the only one to survive beyond 1881, and her parents were devoted to her. Isabella was named after a beloved paternal grandmother, Isabella Tod Stewart—herself a remarkable woman who upon the death of her husband had started a farm in Jamaica, Long Island, and won New York Agricultural Society cups in 1821 and 1828. Isabella Gardner took pride throughout her life in being descended from the royal Stuarts, and the Scottish thistle and white rose appear in ornaments and details throughout Fenway Court (as the museum was known in her lifetime). Her mother's family had arrived in Boston from England in

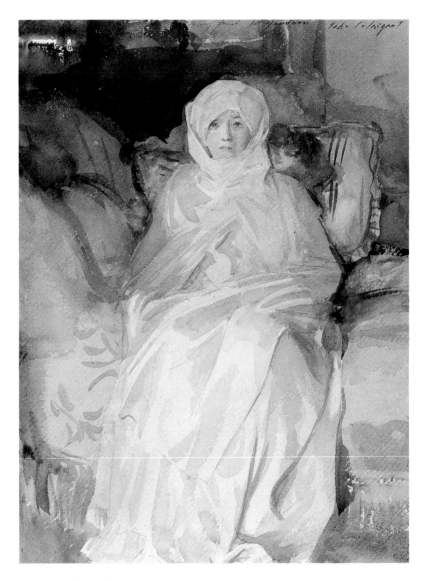

Isabella Stewart Gardner as portrayed by John Singer Sargent in 1922

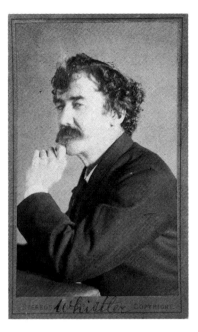

William James's portrait of
Henry James

James McNeill Whistler's
carte de visite

Thomas Sully, *Isabella Tod Stewart*

John Singer Sargent painting in
the Gothic Room, 1903

1650, but they moved to Setauket, Long Island, shortly thereafter and established the township of Smithtown. Adelia Smith's uncle had been a scout for General George Washington.

Isabella Stewart was educated by tutors and at a private school in New York before accompanying her parents to Paris, where she received her "finishing" at a Protestant school from 1856 to 1858 and where she also probably met Jack Gardner. During these two years she traveled with her parents to Italy and visited the wide-ranging collection of Gian Giacomo Poldi Pezzoli in Milan, which included ancient ceramics and bronzes, decorative arts of the Renaissance, books and manuscripts, arms, tapestries, and paintings by early Renaissance and later masters. When Isabella Stewart visited, these works were being installed in rooms theatrically designed to suggest historical periods. Poldi Pezzoli, who died in 1879, created a foundation for the museum's perpetuation for public use. The Poldi Pezzoli Museum evidently made an early and profound impact on the girl, for as Ida Agassiz Higginson recalled to Isabella Gardner in 1923, "You said to me . . . that if ever you inherited any money that it was yours to dispose of, you would have a house . . . like the one in Milan filled with beautiful pictures and objects of art, for people to come and enjoy. And you have carried out the dream of your youth."

On her return from Europe, Isabella Stewart visited her friend and Paris schoolmate Julia Gardner in Boston and soon became engaged to Jack Gardner, Julia's brother. The Gardner family had settled in Salem in the mid-seventeenth century and had moved to Boston in the early nineteenth century with the shifting of the cities' trading fortunes. The Gardners made their fortune as merchants, and by mid-century they owned a fleet of sailing ships. Their activity in the China trade later changed to investment in railroads, mines, and mills.

Jack Gardner and Isabella Stewart were married on April 10, 1860, at Grace Church, New York, and the couple soon moved into a handsome stone house at 152 Beacon Street, a wedding gift from her father. Three years later, in June 1863, Isabella Gardner gave birth to a long-awaited child, John III, nicknamed Jackie, to whom she was devoted. Jackie died less than two years later, and after Isabella Gardner suffered a subsequent miscarriage and was advised by physicians not to attempt to have more children, she fell into a depression, then termed "neurasthenia." On the further advice of doctors, in 1867 Jack Gardner took his wife to Europe for a change of scene. Travel in Scandinavia, including traversing Norway to the North Cape to see the midnight sun, and Russia (St. Petersburg, Moscow, and Novgorod), as well as stops in Vienna and Paris (where Isabella Gardner bought new fashions), completely restored

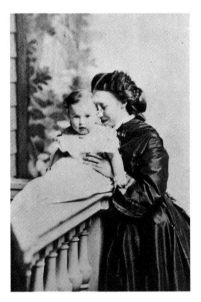

Isabella Stewart, about 1860.
Photo: Boston Athenaeum

Isabella Gardner, photographed
with her son, Jackie, about 1864

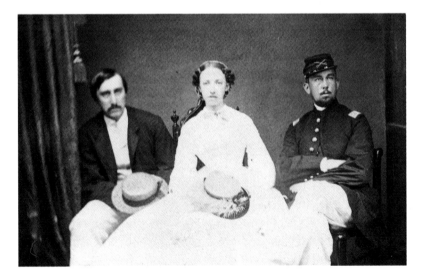

From left to right: John Lowell Gardner,
Isabella Gardner, and B. W. Crowninshield, about 1861

her ebullient personality and zest for life. In her first years of marriage, during the Civil War, with few friends to call on and devoted to maternal duties, Isabella Gardner had evidently determined to conform to the restraining code of conduct expected of Boston matrons in the Victorian era, but now she reemerged as the engaging, open woman she had been before her marriage.

Within a few years the Gardners resumed their unconventional travel, visiting Egypt, Nubia, Palestine, Athens, Vienna, Munich, Nuremberg, and, again, Paris in 1874 and 1875. Isabella Gardner appeared to revel in travel, as seen in these citations from her travel journals, which reveal an adventurousness and interest in historical architecture as well as a lyrical romanticism and openness to exotic cultures and ways of life.

January 1875. [Of Karnak by moonlight.] I have never had such an experience. . . . It was not beautiful, but most grand, mysterious, solemn. I *felt* it, even more than saw it. It was a terrible that fascinated.

January 20. [At Esneh.] The river runs liquid gold and everything seems turned into the precious metal, burning with inward fire; and then the sun sets and the world has hardly time to become amethysts and then silver before it is black night. . . . Everything was so still when the muezzin's call to prayer was wailed through the air that the tears would come.

By this time, she was generating interest in the local press and curiosity among the public in Boston. An anonymous local reporter wrote that year: "Mrs. Jack Gardner is one of the seven wonders of Boston. There is nobody like her in any city in this country. She is a millionaire Bohemienne. She is eccentric, and she has the courage of eccentricity. She is the leader of the smart set, but she often leads where none dare follow. . . . She imitates nobody; everything she does is novel and original." But this popular image (which later spurred Bernard Berenson to characterize Gardner as "Boston's pre-cinema star") must be balanced against one of a woman conscientiously raising three nephews. After the death of Jack's widower brother, Joseph, in 1875, the Gardners assumed responsibility for their nephews' upbringing. In 1879, they took the three boys on an educational tour of French and English cathedrals, lightened by attendance at the Ascot races and at Oxford-Cambridge cricket matches. In London they studied the art collections and visited their countryman Henry James. It was during that visit that James introduced Isabella Gardner to James McNeill Whistler at a party given by Lady Blanche Lindsay. Gardner had first seen Whistler's work at the recently opened Grosvenor Gallery, an independent showroom run by Sir Coutts Lindsay and his wife. Art works for sale were displayed at Grosvenor Gallery in

A page from Isabella Gardner's
travel journal of 1875

an opulent setting, emulating aristocratic residences, and generally hung singly, rather than stacked, on handsomely upholstered walls. The Lindsays exhibited Old Masters as well as works by young artists, including Pre-Raphaelites and Whistler, and also organized special dinners and concerts. Their popular gallery had become a fixture of the London social scene and must have made an impression on the Gardners.

At home, Isabella Gardner was drawn to Boston's intellectual life. Through a valued friendship and possible infatuation with Julia Ward Howe's twenty-eight-year-old nephew, the novelist F. Marion Crawford, she was introduced to the writings of Dante. She attended the

readings of Charles Eliot Norton at Harvard University and joined the Dante Society in 1885. At Norton's encouragement, she began to collect rare books and manuscripts, including early editions of Dante and a selection of Venetian and French sixteenth-century publications. She also became an early supporter of the Boston Symphony Orchestra and its conductors.

After F. Marion Crawford left Boston in 1883, not to see Isabella Gardner again for a decade, she and Jack Gardner embarked on another major voyage. The trip was inspired by a series of lectures on Japan given at the Gardners' home by Professor Edward Morse, one of the first Western specialists in the field, and it culminated in an around-the-world tour. On this voyage Gardner again composed journals, incorporating collages of photographs from the many sites she visited.

Kioto, August 24, 1883. I am writing on the shady verandah and am unconsciously listening to the bells and prayers that come from time to time from the many Buddhist temples. . . . On our way up here we stopped at Osaka, to see the wrestlers! Famous fellows—and it was such fun. The mass of the audience on the ground squatting, the swells in boxes raised ten feet above, the whole in a circle round a small square sanded place in the centre. . . . Brilliant rugs and blankets hanging over the fence of the boxes and what clothes there were (VERY VERY few) were many-coloured, and every human being had a fan. . . . The umpire, whose word is law, starts the match by a movement of his fan . . . and people who wish to make bets write on a slip of paper which they put in the folds of their fan and throw that into the arena. . . . I was immensely amused by a man in the box next to us—his beautiful clothes were carefully laid aside on account of the heat and there he sat, smoking a most beautiful pipe with nothing on but a waist cloth and an European straw hat.

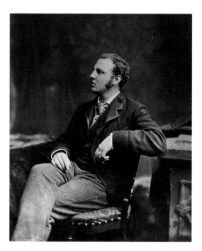

Francis Marion Crawford

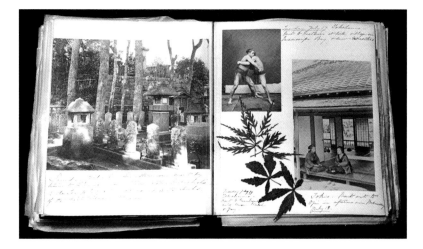

Two pages pertaining to Japan from Isabella Gardner's
travel journal of 1883

The Gardners spent three months in Japan, visiting Yokohama, To-
kyo, Kyoto, Osaka, and Kobe and making the difficult journey to the
venerated temples at Nikko. Isabella Gardner's interest in Japan and
its culture remained throughout her life and was later strengthened by
a friendship with the Japanese artist, connoisseur, and poet Okakura
Kakuzō, who died in 1913.

In Cambodia, the curiosity in ancient monuments Isabella Gardner
had demonstrated years earlier on the Nile led her to visit Angkor Wat by
oxcart. Travel was not without its comforts, however. The Gardners also
enjoyed a dinner, featuring peacock, at the king's residence. "After din-
ner," she commented, "a little tiger was brought in for us to see, a dear,
wild, savage little thing, growled all the time and his Anamite held and
stroked him."

From Cambodia the couple continued to Indonesia, where Gardner's
journal entries reveal a remarkable openness for the period to foreign
cultures and a notably modern sense of humor. At Jakarta, visiting the
residence of an independent prince, she noted:

Beautiful house. . . . The garden full of devices, and cages with beautiful birds,
also a bear, some monkeys, and a little summer house high over all, with charm-
ing view of river. Then the Prince sent word. . . . A nice young fellow, with
beautiful diamonds. All the attendants and people outside on the ground (prone)
. . . from there went to see the imperial tigers and elephants. And while looking at
the latter, a native Prince went in to see the Emperor, stopping at the door to take

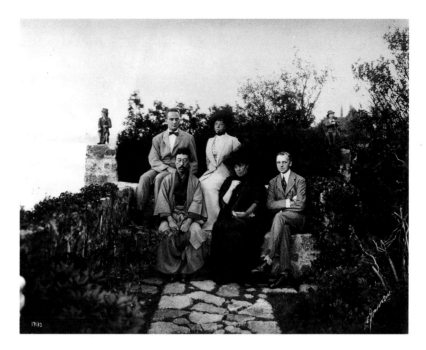

From left to right: (back row) A. Piatt Andrew and Isabella Gardner; (front row) Okakura Kakuzō, Caroline Sinkler, and Henry Davis Sleeper; taken at Red Roof, Andrew's house in Gloucester, Massachusetts

off his jacket, and was quite right, being much better looking in his brown skin. . . . From the hotel verandah we saw a native dancer, to "bamboo" music.

Having worked their way through China, India, and Egypt, the Gardners arrived in Venice in May 1884, where friends surrounded them. Daniel Curtis, a relation of Jack Gardner, had purchased the Palazzo Barbaro on the Grand Canal, and his son, Ralph, showed them around the city. Ralph Curtis was a painter and later advised Isabella Gardner on her collection. Gardner approached Venice with great seriousness, for five weeks studying its art and collecting photographs of works by its fifteenth-, sixteenth-, and eighteenth-century masters. (On subsequent summer trips to Venice the couple sublet the Palazzo Barbaro; its Rococo chambers inspired the installation and design of several galleries of the Gardner Museum and its small interior garden, in which Isabella Gardner wrote letters and took Italian lessons, was reproduced on a grander scale as the courtyard of Fenway Court.)

The Gardners again traveled to Europe in 1886. In London, Henry James introduced Isabella Gardner to John Singer Sargent, who was

living in Whistler's former studio in Chelsea. This began a profound friendship and intimate artist-client relationship—Gardner ultimately owned more than sixty works by Sargent, who visited her often and portrayed her three times, once shortly before her death (a watercolor exhibited in the Macknight Room).

Isabella Gardner's father died in 1891, leaving her an estate valued at $1.75 million. After a period of mourning, she and her husband visited Europe again. This trip was critical to her collecting career, for it culminated in her triumphant acquisition of a Vermeer in Paris. She also purchased works by Whistler and one by Pesellino on this trip. But it was in 1894, with the purchase of the great Botticelli *Tragedy of Lucretia,* that her professional relationship with Bernard Berenson began.

Isabella Gardner had first met Berenson in 1884 when he was a Harvard student enrolled in a class with Charles Eliot Norton. Berenson, a Jewish immigrant born in Lithuania, had excelled at Boston Latin School and Boston University. He transferred to Harvard to concentrate on Semitic languages. Isabella Gardner received the promising young student and his family at Green Hill, the country house in Brookline that Jack Gardner had inherited on his father's death. When several benefactors created a purse to permit Berenson to travel and study in Europe, the Gardners contributed the largest sum. Although Berenson intended to embark on a literary career—his letters to her of 1887 and 1888 are filled

Ralph W. Curtis Bernard Berenson, about 1886

with references to the current literary scene—after his arrival in Florence he focused on Italian painting, beginning the career that would make him the most celebrated connoisseur and art agent of his time. Isabella Gardner had no contact with Berenson for six years, but with his publication of *The Venetian Painters of the Renaissance* in 1894, he reestablished contact with a letter of appreciation. And six months later he was pursuing the Botticelli for her in London. Berenson was Gardner's chief adviser, helping her to acquire many of her greatest triumphs, but he was not her sole adviser. Fernand Robert, Ralph Curtis, Anders Zorn, Henry Adams, and many others assisted Gardner, and she also depended on her own intuition and sense. Her correspondence with Berenson shows her independence of mind. Chiding her for not pursuing a Watteau oil he had recommended, Berenson wrote, "A singular lacuna in your taste is Watteau." On December 3, 1897, she replied, "You have not in the least understood me vis à vis Watteau! I have not that '*Lacuna*' *au contraire,* I like him very much. But not on the Titian line— . . . And when it is a question of not money enough to go round don't you think there are others better for that price? Please think as I do."

With the purchase of Rembrandt's *Self-Portrait* of 1629, and then a Titian and a Velázquez, all in 1896, the Gardners recognized that their ambitions as collectors required more space than their residence at 152 Beacon Street permitted, and they began to consider seriously the creation of a museum edifice. Interestingly, Jack Gardner evidently reached this conclusion first. Isabella Gardner at first sought to convert two adjacent houses on Beacon Street, but he felt that it would be more sensible to buy land and build a new building with an apartment for themselves within it. As Morris Carter, first director of the Gardner Museum, later wrote, "This Rembrandt may be called the corner-stone of Fenway Court, for it was the first picture—so Mrs. Gardner said— that she bought with the intention of developing a real museum collection." Their travel to Venice in 1897 centered on collecting many of the architectural elements for a new building for which sketches of the interior court were probably drawn.

It is easy to see why the Gardners were attracted to the Fenway, the popular new area created by landscape architect Frederick Law Olmsted. In 1878 Olmsted had proposed a system of tidal gates and underground channels to drain and fill in the Back Bay Fens, creating a healthful park landscape. Boylston Street was extended from Exeter Street to the Fenway, and soon thereafter electric transit lines were installed down Huntington Avenue and Symphony Hall was erected on the corner of Massachusetts and Huntington avenues. Nonetheless, though the general

A corner of Isabella Gardner's Red Drawing Room, photographed by
Thomas E. Marr, showing Rembrandt's *Self-Portrait* and Botticelli's
Tragedy of Lucretia

direction of urban development was evident, for the Gardners the attrac-
tion of the Fenway, at the tip of Olmsted's park, was its isolation. Here a
building could have exposure to light and an open vista on all four sides.
(Simmons College moved next door only after Fenway Court's construc-
tion had begun, and the college occupied a building much smaller than
the current one. The Museum of Fine Arts, in its move from Copley
Square, began construction nearby only after Fenway Court had opened.)

The Fenway Court project assumed a new urgency with an unexpected tragedy that must have driven home to Isabella Gardner her own mortality. On December 10, 1898, Jack Gardner died suddenly of a stroke. With single-mindedness of purpose, on January 31, 1899, Isabella Gardner acquired the land on which the current museum stands. Feeling the loss of her husband keenly, she immersed herself in the construction. Gardner truly did design Fenway Court. She insisted that it be built in the marshy Fenway on piles driven down into the landfill (the bedrock is more than ninety feet down) just as a Venetian palazzo would have been. She attended the first pile-driving and regularly visited the construction site, stipulating where each architectural element should go. She climbed up on a ladder with buckets of paint to show the painters the effect she sought for the interior courtyard. She refused to permit steel construction, interceding heatedly and successfully with the building inspector, arguing—correctly, as it turned out—that the structure would be stable and secure if built according to Renaissance building principles.

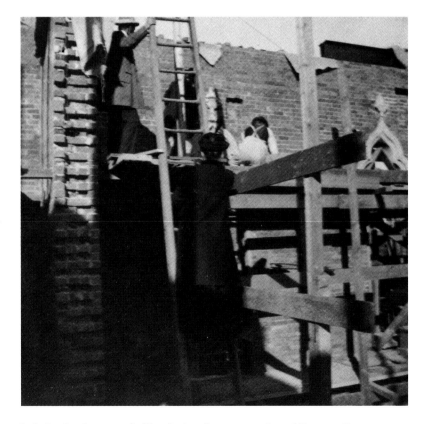

Isabella Gardner on a ladder during the construction of Fenway Court, about 1900

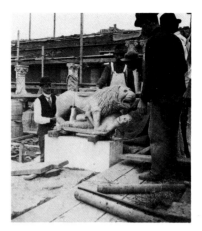

Installation of one of the stylobate
lions in the North Cloister, about 1900

Gardner hired the architect Willard Thomas Sears to assist her. Sears's notes indicate that she was extremely hard on the masons and contractors to get the exact qualities of timber and stone she wanted. She argued with plasterers and plumbers. She made changes constantly, all requiring new drawings and blueprints. She altered the Fenway façade so that the entrance would align directly on the center line of the courtyard. She even insisted that the foundation stone be undressed blocks of varying heights so that the brick edifice would seem to float over the stone course rather than rest on it. Staircases were twice set up and taken down. Hundreds of marked crates filled with columns and stone elements for construction imported from Europe were stored in a warehouse, and Gardner determined the sequence in which they were opened, paying no heed to how they were stacked.

Obstacles and complications notwithstanding, on November 18, 1901, Gardner moved into Fenway Court, the fourth floor always having been intended for her private residence. She had turned the façades of a Venetian palazzo inward on each other to form a courtyard, a graceful oasis filled with flowers, palms, and fountains. Eight balconies overlook a mosaic bought in Rome that is surrounded by Roman statues. At the entrance to the courtyard stand the lion stylobates purchased for Gardner by her husband in Florence. Natural light, which was critical to Gardner, streams through the skylight, bathing the entire courtyard with its evanescent effects.

On December 19, 1900, a charter was established for a corporation "for the purpose of art education, especially by the public exhibition of works of art." And on the night of January 1, 1903, after a year and a half of building and an equal time of installation, guests were invited to a

private concert in the music room (now the Spanish Cloister and Tapestry Room), featuring works by Bach, Mozart, Schumann, and Chausson performed by fifty members of the Boston Symphony Orchestra. At the end of the performance, mirrored doors that blocked the view to the courtyard were rolled back, and the interior, lit by Japanese lanterns and filled with flowers, its galleries illuminated by candles, was opened to the guests. The reactions were dependably unanimous and rapturous. William James wrote to Gardner, "The aesthetic perfection of all things . . . seemed to have a peculiar effect on the company, making them quiet and docile and self-forgetful and kind, as if they had become as children. . . . Quite in the line of a Gospel miracle!" The public was admitted in February 1903. Attendance was at first limited to two hundred a day for twenty days each year—ten days' each at Easter and Thanksgiving— with a one-dollar fee to keep out the merely curious. "As long as such a work can be done," wrote Henry Adams, "I will not despair of our age, though I do not think any one else could have done it. . . . You are a creator and stand alone."

Isabella Gardner's benefactions also extended to the support of artists and musicians (she bequeathed a cello to the young Pablo Casals), animal rights societies, the Boston Zoo, literary associations, hospitals, and the Episcopal church. Her interest in horticulture extended to her offering a series of prizes for tenement house gardens. She also avidly supported the various Harvard teams and delighted in the Boston Red Sox. Her motto, "C'est mon plaisir," expressed as much her pleasure in availing the arts to the public as a pleasure in her individuality. Her seal for the museum bears that motto and a phoenix, symbol of immortality. Henry James summed up her accomplishments in describing the Gardner Museum as "results magnificently attained." When the Museum of Fine Arts opened the doors at its new Fenway location to the public in November 1909, by which date Gardner had made most of her acquisitions, the Fenway Court collection of European art was more distinguished than the holdings of the Museum of Fine Arts.

On the occasion of Isabella Gardner's birthday in 1911, the painter and Harvard art lecturer Denman Ross wrote her on behalf of the assembled company,

There is no one of the Fine Arts in which you have not taken serious interest; no one of them to which you have not given a generous patronage. We have seen your devotion to the arts of Dancing and Music, to the Drama and to Literature. As for the arts of Sculpture and Painting you have illustrated them in a Collection of masterpieces which is known all over the world. You have built this beautiful

Isabella Gardner and one of her dogs at Green Hill, Brookline, about 1906; with her is Giuseppe della Gherardesca

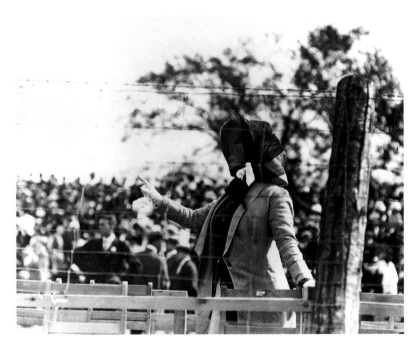

Isabella Gardner photographed by Galaid at the Harvard-Boston Air Meet, Squantum, 1910. Photo: Bostonian Society

house, yourself the Architect, and have filled it full of Treasures. You are, not only the lover of Art, and the Collector, but the Artist, having built the house and having arranged all the objects which it contains in the order and unity of a single idea—an idea in which you have expressed your whole life with all its many and varied interests.

Throughout her life Isabella Gardner was interested in what was new in all realms of artistic exploration—literature, music, art. Her collecting habits reflected an evolving aesthetic. Whereas in the 1870s as a young woman she seems to have been interested in fashions and jewels, buying a few American and French academic works, by the 1880s she began to collect books and to acquire Old Masters, as well as recent and contemporary artists of repute, such as Eugène Delacroix, Jean-Baptiste-Camille Corot, Gustave Courbet, Whistler, Sargent, and John La Farge. She also supported the young American Impressionist Dennis Miller Bunker. By the 1890s, her patronage had expanded to include Anders Zorn at the same time she was acquiring her most celebrated Old Masters. In the first decade of the new century she acquired her first oil by Edgar Degas and many more works by young Boston painters. Between 1910 and 1923, together with the occasional work by Giovanni Bellini or Bernardo Daddi, the collection (also reflecting her more limited means as she became concerned with establishing an endowment) was expanded primarily through acquisitions of contemporary painters (Dodge Macknight, Louis Kronberg, and Leon Bakst) but was also highlighted by her pieces by Edouard Manet, Degas, and Henri Matisse, as well as sculptures by Paul Manship. Twentieth-century abstraction, however, remained a frontier she could or would not cross, though she covered the vast ground from antiquity and Old Masters to Fauvism and Art Deco at its cutting edge.

In December 1919, Isabella Gardner suffered a debilitating stroke that paralyzed her right side, though she could still move about and visit friends. She died peacefully five years later, on July 17, 1924. She was buried with her husband and son at Mount Auburn Cemetery, Cambridge. Her faithful niece, Olga Monks, wrote Bernard Berenson that September, "It seems strange to go to Fenway Court and lonely. Bolgi [her devoted assistant] told me a few days ago that he often thought he heard her calling him, but her people work as they feel she would have wanted them to do and the place must always remain live for that was the idea in the original conception and in the execution of the idea, a living message of the beauty in art to each generation."

Theobaldo Travi (Bolgi) in the North Cloister of Fenway Court, 1902

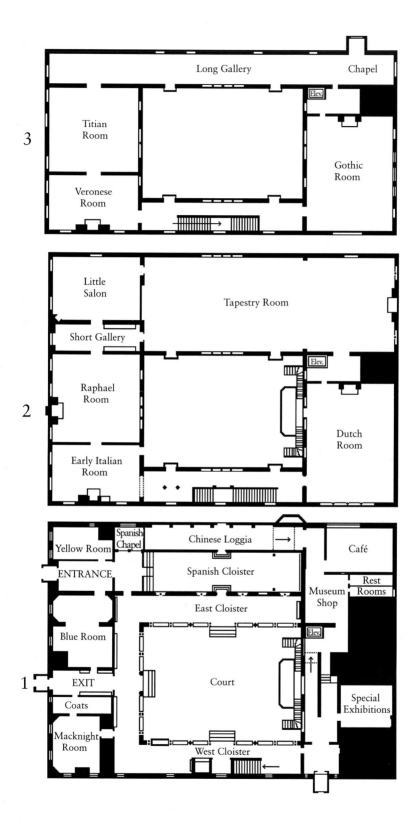

3

Long Gallery · Chapel

Titian Room

Elev.

Gothic Room

Veronese Room

2

Little Salon

Tapestry Room

Short Gallery

Elev.

Raphael Room

Dutch Room

Early Italian Room

1

Yellow Room

Spanish Chapel

Chinese Loggia

Café

ENTRANCE

Spanish Cloister

Rest Rooms

Museum Shop

East Cloister

Blue Room

Elev.

EXIT

Court

Coats

Special Exhibitions

Macknight Room

West Cloister

Ground-floor Rooms

The three rooms (Yellow, Blue, and Macknight) off the courtyard and cloisters are notable for their calculated intimacy and informality—their almost bric-a-brac juxtapositions of paintings, sculptures, drawings, pastels, letters, manuscripts, ceramics, decorative objects, and artifacts. Unlike the objects in the formal rooms upstairs on the second and third floors, most of the art works in these rooms were acquired after Fenway Court opened in 1903. Until 1915 the Macknight Room was actually a guest bedroom and was not opened to the public. These spaces were never intended to have the impact of the grand galleries or courtyard. Originally one entered the building through the current central exit, and these rooms functioned as lounges and places to gather before concerts,

The Blue Room, with a view toward Edouard Manet's *Mme Auguste Manet*

which were held when the current Spanish Cloister and Tapestry Room above it served as the two-story Music Room. The Yellow Room, which measures about twelve by twenty-three feet, evidently functioned as a subsidiary lounge and green room for performers.

The Yellow Room

On entering the museum today, the first gallery we see, the smallest and least public in Isabella Gardner's original vision, is the Yellow Room. It contains two oils by Whistler, portraits by Sargent and Degas, and a critical painting by Henri Matisse (1869–1954), **The Terrace, St. Tropez,** dated 1904—the first Matisse to enter an American museum.

In the two cases along the west wall are memorabilia, autographs, photographs, and signed dedications of musicians and composers, suggesting the room's original association with the former Music Room. Many of these figures were acquaintances of Isabella Gardner, including Dame Nellie Melba, Jules Massenet, Ignace Paderewski (with his handwritten program of the recital he played for her at which she was the sole audience), Johann Strauss, Eugène-Auguste Ysaÿe, Anna Pavlova, and others. The cases also contain mementos and manuscripts associated with Beethoven, Franz Liszt, and Tchaikovsky and a sketch of the young Jascha Heifitz by Sargent. In the case on the east wall is a rare viola d'amore made by the eighteenth-century Neapolitan violin-maker Tomaso Eberle. It was given by the violinist and composer Charles Martin Loeffler to his patron, Isabella Gardner, on her birthday in 1903.

The room is filled with American and European nineteenth-century paintings. **A Lady in Yellow,** by Thomas Dewing (1851–1938), was exhibited in Boston in 1888. The affecting dreamlike gaze and elegant, simple profile pose of the sitter are complemented by the handsome frame designed for Dewing by his friend the architect Stanford White. To the right is an oil sketch of Loeffler by his friend John Singer Sargent. It was painted at Fenway Court on the afternoon of Good Friday (April 10) 1903 and, as alluded to in the inscription, "To Mrs. Gardner, con buone feste from her friend John S. Sargent," was a birthday present. Gardner celebrated the occasion with a concert of music composed by Loeffler. At the far end of the wall is the painting **Love's Greeting** by the foremost Pre-Raphaelite painter, Dante Gabriel Rossetti (1828–1882). The painting derives from a composition designed as the frontispiece for his book of translations entitled *The Early Italian Poets from Ciullo d'Alcamo to Dante Alighieri* (1861). The work, which Gardner bought in 1892,

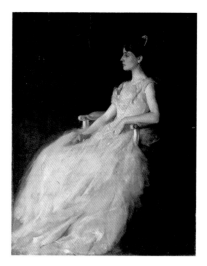

Thomas Dewing,
A Lady in Yellow

evokes English romanticist images of a late medieval Italy that combines chivalry and attraction with chastity.

Along the east wall of the room, opposite the entrance, are two paintings by James McNeill Whistler (1834–1903) flanking a painting by Edgar Degas (1834–1917). Whistler's **Harmony in Blue and Silver: Trouville** is an early oil, dating to the summer of 1865. The single figure who looks out from the coast to a placid sea dotted with two sailboats is the artist Gustave Courbet, who was then painting his celebrated large, dynamic seascapes at Trouville. Isabella Gardner's purchase of the painting in 1892 wonderfully illustrates her persistence. As the story is related, she had admired it on several occasions, and Whistler agreed to sell it to her but then found he couldn't part with it. Finally she went to his Paris studio with William Rothenstein, Whistler's assistant. On her orders, Rothenstein took it off the wall and down the stairs to the carriage with Isabella Gardner stationing herself protectively behind him, Whistler in pursuit, protesting that he hadn't quite finished it and that it wasn't signed. She invited him to her hotel for lunch the next day, where he signed it, applying his celebrated butterfly signature.

By contrast, **Nocturne, Blue and Silver: Battersea Reach** dates to the 1890s. Isabella Gardner bought the work from Whistler in 1895. He was then living in Chelsea, across the Thames from Battersea. In this smoky blue twilight study of London, compositional organization is addressed in virtually abstract terms. The illuminated clock tower and a few faint quayside lights emerge as orange dots in the distance from the tenebrous fog of this tonal study, while a rowboat cuts a diagonal swatch in the left foreground.

Between the two Whistlers, Isabella Gardner placed Degas's portrait of **Mme Gaujelin,** dated 1867. The prim subject of this work is Josephine Gaujelin, a beautiful ballerina who became an actress and who rejected the painting, though she had commissioned it. She evidently found it unflattering and complained of its pose. In this uncompromising, even harsh portrait of the young woman, Degas posed her seated on a white sofa, dressed in black, sternly confronting us, her form tightly compressed on a patterned burgundy fabric. The sharp, focused severity of the work is typical of Degas's photography-influenced portraiture.

Matisse's painting **The Terrace, St. Tropez,** was a gift to Isabella Gardner in 1912 from Thomas Whittemore, who had bought it from the artist. The painting was executed during the summer that the artist spent with the celebrated pointillist Paul Signac and includes an image of Matisse's wife in a kimono, resting her back against the boathouse while she concentrates on the needlework that had helped support them. The piece marks a critical moment in Matisse's transition from a more traditional painting style to the looser, more brilliant colorism of his Fauve period. The work, as Matisse preferred, has never been varnished and is in excellent condition.

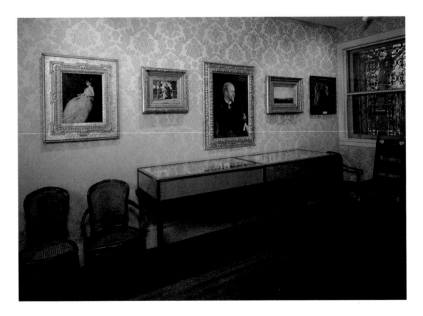

The Yellow Room, with Thomas Dewing's *A Lady in Yellow* (far left), John Singer Sargent's portrait of Charles Martin Loeffler (center), and Dante Gabriel Rossetti's *Love's Greeting* (far right)

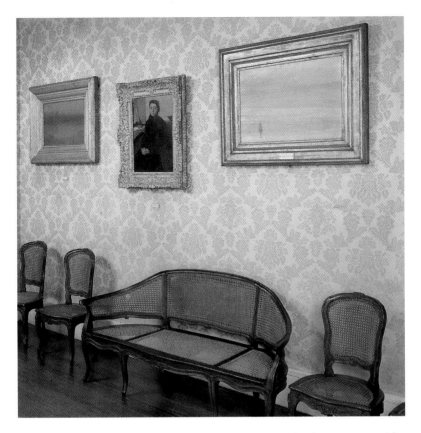

The Yellow Room, opposite wall: James McNeill Whistler, *Nocturne, Blue and Silver: Battersea Reach* (left) and *Harmony in Blue and Silver: Trouville* (right), and Edgar Degas, *Mme Gaujelin* (center)

Henri Matisse, *The Terrace, St. Tropez*

The Blue Room

The Blue Room includes several of Isabella Gardner's most noteworthy acquisitions in nineteenth-century art, including works by Manet, Sargent, Zorn, La Farge, Delacroix, Corot, Courbet, Bonheur, Bunker, and Hassam. The cases about the room include letters and photographs of many leading American literary figures of her time, among them Ralph Waldo Emerson, Henry and William James, Oliver Wendell Holmes, Henry Wadsworth Longfellow, Henry Adams, Walt Whitman, and George Santayana. The Blue Room reflects Isabella Gardner's maturing tastes, encompassing several of her earliest Boston purchases, safe and traditional, such as a Courbet and a Corot bought by 1880, works by bolder young artists she championed in the 1880s and 1890s, such as Bunker and Zorn, a Manet acquired in 1910, and a nearly abstract Sargent view of waterfalls in the Canadian Rockies, painted in 1916.

The Omnibus, by Anders Zorn (1860–1920), occupies the spur wall opposite the entrance to the gallery. Isabella Gardner purchased the painting from the artist, who was installing the work at the World Columbian Exhibition in Chicago in 1893. It was the beginning of a long and meaningful friendship between them. Zorn was a prominent Swedish Impressionist who had attained great recognition in Europe, and Gardner promoted his art in the United States. The dynamic picture is a

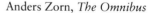

Anders Zorn, *The Omnibus*

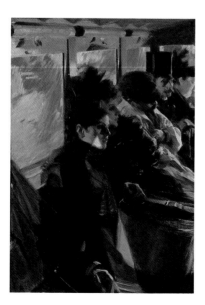

commentary on urban transit; it depicts a modern trolley car filled with a cross section of humanity—blue-collar workers, a milliner, and a gentleman with a tophat—all tightly packed yet alienated from one another. All are painted with loose, aggressive, schematic strokes, emphasizing white, blacks, and grays. Isabella Gardner placed the work so that morning light coming in through the window would complement the dramatic, diagonal shard of light in the painting.

On the opposite wall is a small, wonderfully fresh and light-filled watercolor by John Singer Sargent, one of several in the room. **A Tent in the Rockies,** dated 1916, is one of eleven watercolors Isabella Gardner acquired from the artist. It is a bravura demonstration of Sargent's ability to capture a broad range of whites through subtly applied tones and the use of the white paper itself in depicting a canvas tent bathed in sunlight against a richly forested backdrop. That same year, she acquired **Yoho Falls,** a vivid and nearly abstract rendering of the falls at a site in British Columbia. The large canvas was executed during the same trip in the summer of 1916 as the watercolor. Sargent took a vacation at this time from supervising the installation of his murals at the Boston Public Library. He noted that after having been attracted to the site during the first two days of sunlight, "mushrooms sprouting in my boots, porcupines taking shelter in my clothes," and rain and snow caused him to lose his fascination with the "fine waterfall which was the attraction to the place pounding and thundering all night." Nearby is his oil sketch for **Astarte,** part of the decorations for the Boston Public Library. Gardner bought the sketch in 1896.

On the spur wall opposite Sargent's painting is his small oil sketch of a subject of personal interest to Isabella Gardner, **Mme Gautreau Drinking a Toast.** Gautreau, born Virginie Avegno in New Orleans, was the daughter of a Confederate officer killed in the Civil War. Her mother brought her to Paris, where she married a banker, Pierre Gautreau. She was renowned for her great beauty, décolleté dresses, and lavender pancake makeup. She was also a mistress of Paris's handsome society physician Samuel-Jean Pozzi (from whose collection Gardner acquired this oil sketch at auction in 1919). Sargent's portrait of Gautreau, the scandalous *Madame X,* now at the Metropolitan, was the sensation of the Salon of 1884. Gardner saw it in Sargent's studio in Chelsea in 1886 when she visited with Henry James, and it undoubtedly contributed to her decision to commission her own portrait the following year. No doubt these memories guided her in the acquisition of this charming sketch, which in its intimate scale and energized brief strokes captures the ravishing charm of the young woman.

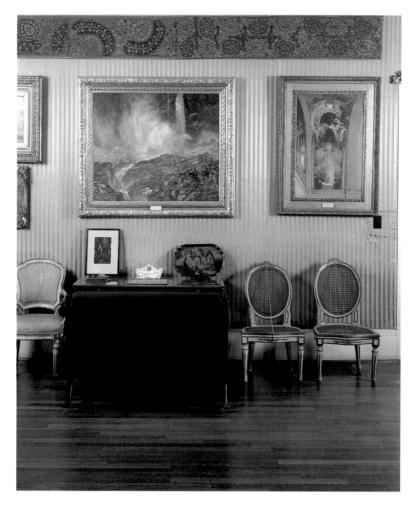

The Blue Room, with John Singer Sargent's *Yoho Falls* (left) and *Astarte*

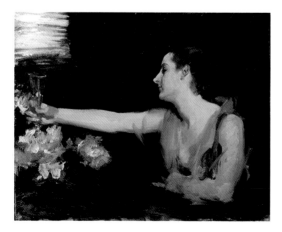

John Singer Sargent,
Mme Gautreau Drinking a Toast

Mme Auguste Manet, by Edouard Manet (1832–1883), occupies the far south wall of the room. The powerful portrait of Manet's mother, widowed in 1862, is executed in broad strokes in a masterly range of blacks. Mme Manet came to live with her son and his bride after their marriage in 1863. The painting appears to reflect the influence of Diego Velázquez (1599–1660), whose art Manet saw when he traveled to Spain in 1865, and it may well date to about that time. The stark, planar contrast of unmodeled face and hands with a boldly brushed palette of blacks and browns suggests the direct experience of Spanish painting.

Isabella Gardner was proud of her support of young contemporary painters, whose work she championed from the 1880s to her death. Among the American painters she encouraged, Dennis Miller Bunker (1861–1890) was one of the most talented, his promising career cut tragically short. Among the several works by Bunker in the Blue Room, the two most important, **Chrysanthemums,** of 1888, and **The Brook at Medfield,** of 1889, boldly assert his early adoption of an Impressionist palette, subject, and brush stroke.

The Macknight Room

The final ground-level room off the central cloister is the Macknight Room. This small room was opened to the public in April 1915, having served earlier as a private parlor and guest room. It is named for the New England artist Dodge Macknight (1860–1950), whose art was influenced by Sargent. Macknight was a popular watercolorist and a favorite

Edouard Manet,
Mme Auguste Manet

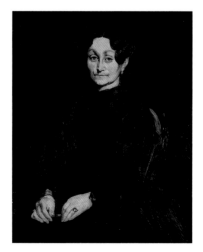

The Blue Room, southwest corner, with Dennis Miller Bunker's
Chrysanthemums high on the wall

of Gardner's; early in their acquaintance, in 1904, he wrote her, prophetically, that he did not seek her "to buy my pictures by the bushel to start a
Macknight room at Fenway Court."

Two works in this room are of particular note. In 1922 Sargent created his most evocative image of Isabella Gardner, **Mrs. Gardner in
White,** in the evanescent medium of watercolor. Inscribed "To my friend
Mrs. Gardner," the work enchanted her. "Even I think it is exquisite" she
wrote. The watercolor portrays her at the age of eighty-two, after her
debilitating stroke of 1919. With her form wrapped in white drapery,
which itself seems to dissolve and deny mass and volume, the image
becomes a haunting vision of her inhabiting spirit, alert and focused,
facing the viewer and death alike. As iconic as the portrait Sargent
painted of her thirty-four years earlier, it is all the more powerful for its
intimacy and austerity.

At the opposite end of the room, in front of the mirror, is Paul Manship's **Diana,** of 1921. The bronze is among the artist's most celebrated
works. Manship (1885–1966) chose to depict the Roman goddess of the
hunt in the act of flight and chase, selecting a moment of optimal rhythm
and movement as he captures her in midair, leaping as she looks back
toward her victim, the hunter Actaeon. Accompanied by her hunting

The Macknight Room, with Dodge Macknight's watercolors around the room at the top

dog, she pulls on the invisible string of her bow to release an arrow. The highly stylized figure is reduced to a sharply defined silhouette and clear linear rhythms, smooth and streamlined. Manship was the greatest American sculptor in the Art Deco style. Gardner acquired **Diana** from the artist through his New York dealer in 1921, and the sculpture is a

John Singer Sargent,
Mrs. Gardner in White

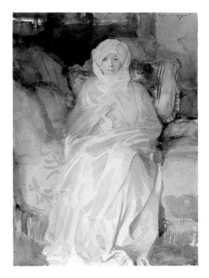

testament to her abiding interest in contemporary art, even at the age of eighty.

The Cloisters and Courtyard

On entering the Gardner Museum today, we walk through what had been the egress of Fenway Court in Isabella Gardner's lifetime. It frames a dramatic view of one of the most popular works in the collection: John Singer Sargent's **El Jaleo**, of 1882. This effect was carefully planned, for in 1914 Isabella Gardner restructured her Music Room into two stories of galleries: the Spanish Cloister and, above it, the Tapestry Room. As early as 1906 she began to collect materials for the future galleries, and by 1908 she had laid out plans for the new spaces. The Spanish Cloister is a testament to her vision—and optimism. The space was designed not merely to house *El Jaleo* but to serve as a theatrical setting for Sargent's early masterpiece. Yet at the time she did not own the painting: it was in the possession of her cousin by marriage, Thomas Jefferson Coolidge. By the beginning of the century, Isabella Gardner was already a major collector of Sargent. Recognizing the importance of the painting and disturbed that it was exhibited inadequately, with lighting from above rather than below as the work's internal lighting demanded, she created for it the most elaborate installation in the entire museum. Coolidge gave Isabella Gardner the painting after he had seen her arrangements. (He had, in any case, moved to a new house into which it would not fit, and his son, to whom he had once intended to give the picture, had died.) The painting arrived at Fenway Court in December 1914.

It was as though Gardner sought to replace the concerts and theatrical productions she once held in the space with a permanent performance. *El Jaleo,* roughly translated "the ruckus," is an evocation of synaesthetic experience: the clicking of heels, the snapping of fingers and slapping of hands, the chant of the singer and sound of the guitar, the shimmering of the improbably colored skirt, and the heady atmosphere of the Andalusian cavern taverna outside Seville. All are conveyed with rapid, turbulent brush strokes and flamelike coloristic highlights against a dark indoor setting. Gardner set the painting behind a Moorish arch so that the viewer appears to see the performance on an electrically illuminated stage. When Sargent saw the installation in 1916 he was entranced, and in 1919 he presented Isabella Gardner with a tribute, a sketchbook he had created of his preparatory studies for the painting.

Gardner had twice traveled to Spain, once with her husband in 1888 and, significantly, again during her last European voyage in 1906. Dur-

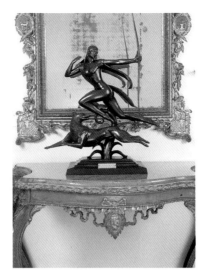

Paul Manship, *Diana*, in situ

ing the second trip she bought architectural elements, including the Hispano-Moresque window that "frames" the picture, for use in the Spanish Cloister and adjacent chapel. In 1909 the artist Dodge Macknight found for her the colored tiles that cover the walls: fifty crates containing nearly two thousand seventeenth-century Mexican tiles that had once been the pavement of a church. Gardner spent many hours assembling them into patterns that would be appealing on the walls, in the manner of architectural decorations of southern Spain and Portugal. The long wall is pierced by a Romanesque **portal,** dating to the late twelfth century, originally the entrance of an important private house in La Réole in Bordeaux.

To the left of the cloister is an enclosed porch known as the **Chinese Loggia.** It contains a remarkable temple stele, a Buddhist votive piece dating to A.D. 543, of the Eastern Wei dynasty. On the base is an inscription listing seventy-eight benefactors. The sculpture has been carved in two conventions. On the primary side, the Buddha is shown with two monks and two bodhisattvas, all carved in high relief. The Buddha is dressed in Chinese fashion. On the reverse, in low relief, the Buddha Sakyamuni is shown raised heavenward in conversation with the Buddha Prabhutaratna. The sculpture is perched on lotus petals and supported by a dragon. Nearby is a polychrome gilt wooden sculpture of **Kuan-Yin,** the bodhisattva of compassion, a Chinese work of the eleventh or early twelfth century that depicts the figure seated in repose, a pose adopted from India and popular in China into the fourteenth century.

To the left, just before the steps to the Spanish Cloister, is a far more

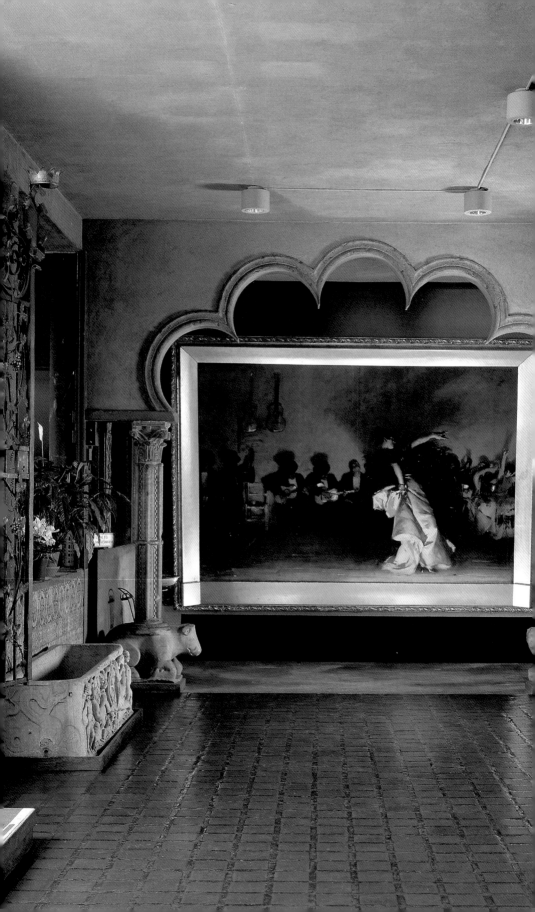

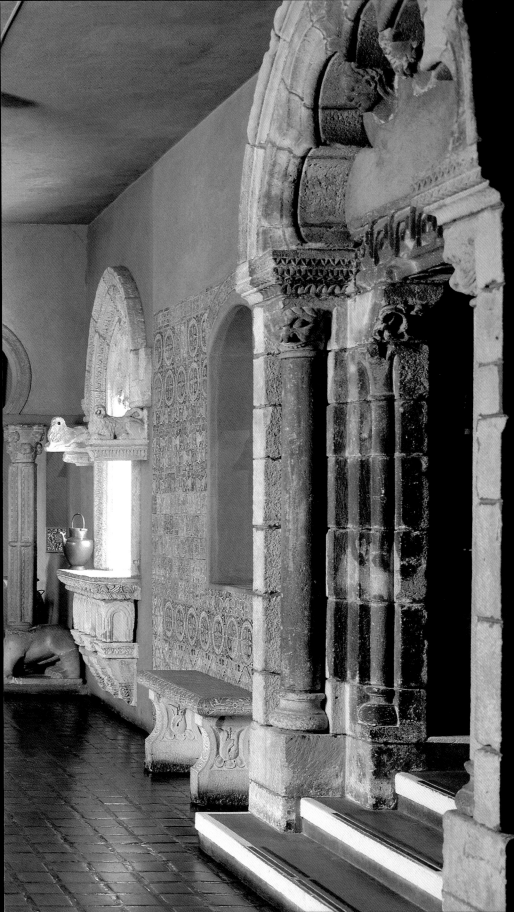

Romanesque portal from Bordeaux, surrounded by Mexican tiles

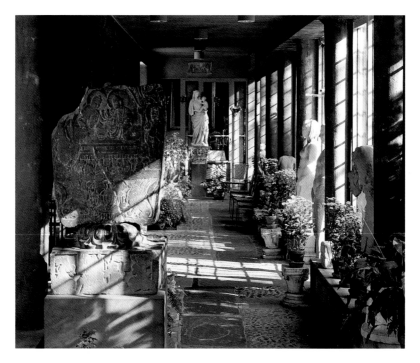

The Chinese loggia from behind the votive stele (left)

Overleaf: John Singer Sargent, *El Jaleo,* Spanish Cloister

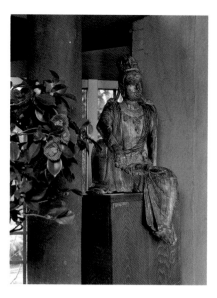

Kuan-Yin, eleventh- or early
twelfth-century Chinese

personal space, the Spanish Chapel. The space was clearly dedicated in Gardner's mind to her infant son, Jackie, who had died nearly fifty years earlier. In it she placed the **Virgin of Mercy** from the studio of Francisco de Zurbarán (1598–1664), a work of about 1630–1635 that had hung in her bedroom and that she had bought during her visit to Seville in 1888. On the floor is a Spanish **Tomb Figure of a Salamancan Knight** of the Maldonado family, a work dating to about 1500, acquired during Gardner's second trip to Spain.

Moving into the central cloisters, along the wall on the right is a Lorraine limestone **Retable with Scenes of the Passion,** datable to about 1425 and executed with the intricate carving, tracery, and attention to surfaces characteristic of late Gothic sculptors active in Lorraine and Champagne. The six scenes from the Passion, from the *Arrest* to the *Three Marys at the Tomb,* are flanked at each end by the donors, Guillaume (his coat of arms at his feet) and Gudelette Bouvenot.

At the central opening to the courtyard itself, opposite the original museum entrance, two delightful **lion stylobates** support the columns, a whimsical juxtaposition. The Tuscan lion on the right dates to the second half of the twelfth century, its origin expressed with minimal detailing, primarily the flamelike pattern of the lion's mane behind the weighty head, which conveys a sense of architectonic mass. There is little doubt that this figure supports the column. The man caught beneath drives a knife into the lion's flank. Opposite rests a north Italian late twelfth- or early thirteenth-century stylobate carved in red marble. The sculptor has exploited the coloring of the stone and carved into it so as to minimize the

The Spanish Chapel, with the tomb knight and the *Virgin of Mercy*

sense of mass of the lion and accompanying atlante that support the column. By emphasizing textures and rhythmic patterns, the artist exalts the sensuous surfaces of the richly colored stone.

More than any single work of art, however great, housed within Fenway Court, it is the experience of the courtyard that endures in the minds and hearts of its visitors. The stonework arches, columns, and walls—set as though jeweled, with fenestrations and architectural and decorative elements—create an unforgettable impression. With a creativity found in early Venetian palazzi, Isabella Gardner integrated Roman, Byzantine, Romanesque, Gothic, and Renaissance elements and multicolored stone columns to form a remarkably harmonious and sensually stimulating whole. The **balustrades** of the east and west sides on the second and third

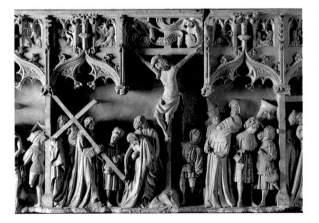

Retable with Scenes of the Passion, Lorraine, detail

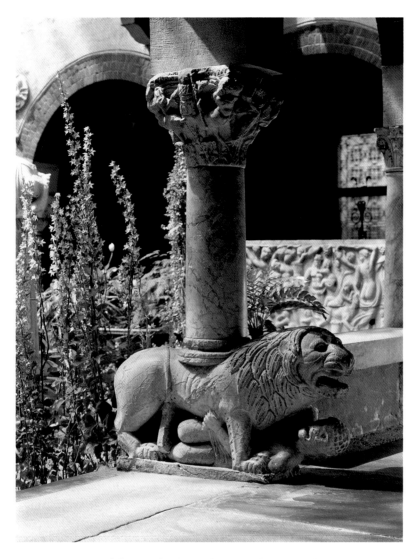

One of the North Cloister lion stylobates, twelfth-century Tuscan

floors come from the celebrated Cà d'Oro in Venice. Most of the court-yard's architectural and decorative elements date from the twelfth through fifteenth centuries and were acquired in Venice during 1897. To achieve the atmospheric coloring of the stucco, Isabella Gardner, in her sixties, intervened with the painters, and demonstrated with a brush and buckets of paint the rough brushwork she wanted. The effect, as though a Venetian palazzo's façade had been turned in on itself, richly evokes that city. What is distinctly American and nineteenth century about the effect is the disciplined order and severe symmetry she has brought to the

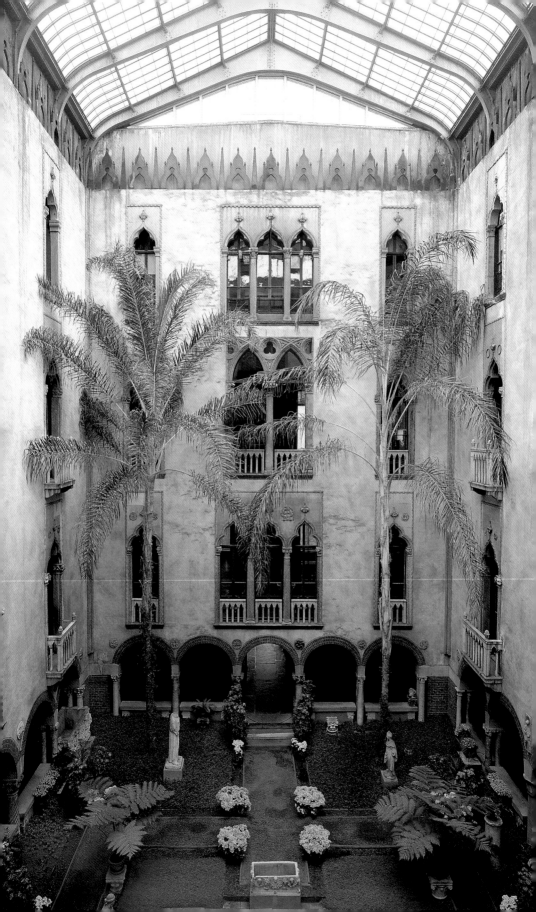

whole. The courtyard remains very much an American's caprice, albeit an exquisitely sensitive one, inspired by the experience of Venice.

At the center of the courtyard lies a fine second-century Roman **mosaic.** At its center is a Medusa head, a common motif in such pavements, intended to ward off evil spirits. Medusa had the power, through her hideous appearance, to turn anything that looked on her to stone, and she is appropriately surrounded by stone figures. These include the Egyptian **Horus Hawk,** a Ptolomaic piece, behind the mosaic, and on the wall beyond, the Greco-Roman **Relief of a Maenad.** The **Odysseus Creeping Forward during the Theft of the Palladium,** placed in the arch to the far left as one faces the back wall, is a rare Greco-Roman depiction of the theft of the Trojan talisman by the Greek hero, as related by Ovid. The sculpture was created for a pediment and dates to about 50 B.C.

Just beyond, on axis with the mosaic, is a Roman late second-century **throne,** reflecting a Near Eastern influence in the bearded winged figure on the back and in the decorative vegetative forms that ornament it. At the rear of the court Isabella Gardner placed two **enriched shafts,** Roman works of the first or second century A.D., acquired in Florence in 1899. In antiquity such decorative shafts would have been placed at the entrances of shrines or parks. The courtyard contains an ever-changing installation of plants and flowers. Horticulture was always dear to Isabella Gardner, and the museum maintains greenhouses both on- and off-site. At Eastertide, nasturtiums are hung from the terraces.

Along the edge of the courtyard in the West Cloister is the most important work of ancient art in the collection, the **Sarcophagus with Maenads and Satyrs Gathering Grapes,** a Roman sculpture from the Severan period (A.D. 222–235), commonly known as the **Farnese Sarcophagus.** Carved along the four sides of the sarcophagus are maenads, satyrs, and erotes, interacting amorously and gathering grapes in their capacities as devotees of Dionysos (in Roman mythology called Bacchus), the god associated with grapes, wine-making, and fertility. As the deity of fertility and rebirth, Bacchus was associated with the belief in the immortality of the soul and the regeneration of the spirit. The decorative grapevines also underline the symbolism of the sarcophagus, as vines appear to wither and die each winter but flourish anew each spring. The sarcophagus is superbly carved. Although the processional figures are arranged in strict symmetry around the central dancing figures of the man and woman, the interlocking arms of the figures, slight variations in poses, and stream of small children at the bottom create a wonderfully dynamic composition in relief. The sarcophagus was first documented at

The courtyard, looking north

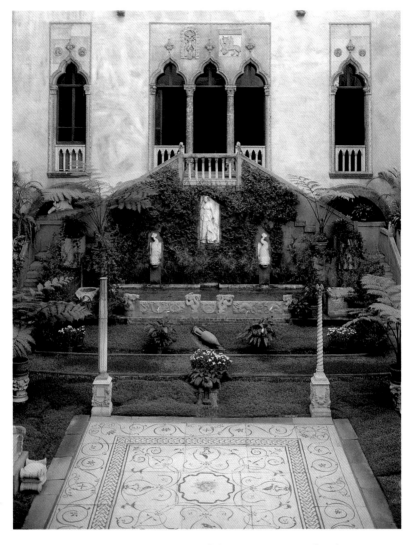

The second-century Roman mosaic amid the many stone works of
the courtyard

the Villa Farnesina in Rome in 1556, having supposedly been unearthed
at Tivoli, and from there it was carried to the Palazzo Farnese, where it
appears in drawings of about 1620.

On the wall opposite the stairs to the first grand floor of galleries, the
piano nobile, is the **Madonna della Ruota della Carità,** dated 1522, a
sculpture by Giovanni Maria Mosca (active 1515–1573) of Padua. The
Virgin is seated on a heavenly throne holding a wheel of charity (the
Greek cross interlacing two concentric circles), the adopted symbol of

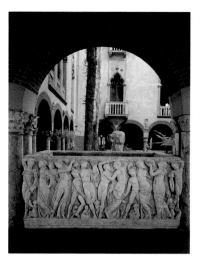

Odysseus Creeping Forward during the Theft of the Palladium, Greco-Roman

The Farnese Sarcophagus

the Venetian Scuola della Carità (confraternity of charity). The work contains the coat of arms of Paolo da Monte. Isabella Gardner recollected that during her visit in 1897 she had seen workmen cutting the piece out of the wall of the abandoned Abbazia della Miseracordia, to which it had been relocated at an unknown earlier date, and she acquired it at that time.

Giovanni Maria Mosca, *Madonna della Ruota della Carità*

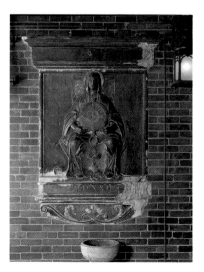

Second-floor Rooms

The Early Italian Room

The small artistic treasure house that is the Early Italian Room is the anteroom, both physically and conceptually, to the art works of the Italian High Renaissance that lie beyond. This room houses works by several artists associated with the "rebirth" of Italian art in the fourteenth and fifteenth centuries in a space originally intended for a quite different purpose. From the opening of the museum in 1903 until 1913, this room held Isabella Gardner's collection of East Asian art. As her collection of early Italian art continued to grow, she shifted the East Asian collection to the rear halls on the second and third floors and to private rooms. Still situated in the gallery, however, and among the more popular sculptures in the collection, are two delightful and rare solid-cast Chinese gilt bronze **bears** that date from the early Han dynasty (206 B.C. to A.D. 214). They can be found in the glass case to the left of the fireplace. The "fire-breathing" dragons that decorate the hood of the fireplace rather amusingly testify to the room's original association with Asia.

Some images powerfully suggest an interpretation even though definitive documentary confirmation is lacking. Such is the case for the large detached fresco (pigment dissolved in water and applied to wet plaster) of **Hercules,** to the right as one enters the room from the hallway. The *Hercules* fresco was created by Piero della Francesca (ca. 1416–1492) to decorate the public room of his grand residence, which he designed and began to build in 1465 on the main street of his native town, Borgo Sansepolcro. This is the only fresco by Piero outside Italy and his only treatment of a mythological subject—it speaks to Piero's civic pride, interest in classical antiquity, mathematical concerns, and study of classical proportions and perspective. It also indicates the emerging sense of esteem in which artists were held in the Renaissance and in which in turn Piero held himself.

The almost life-size fresco, probably begun about 1467, may once have been complemented by a self-portrait. Given the scale of the original room in which it was painted, however, it could also have been intended

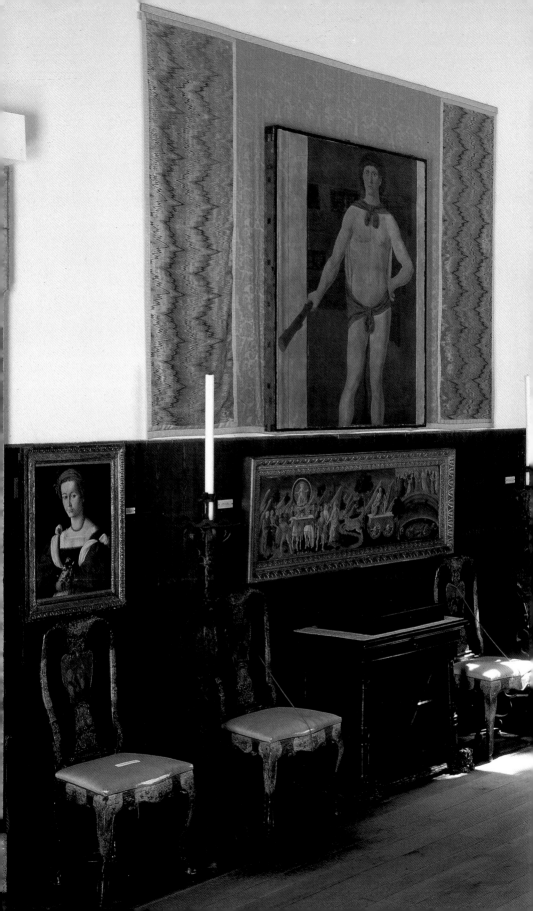

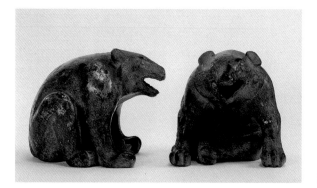

Bears, Han dynasty

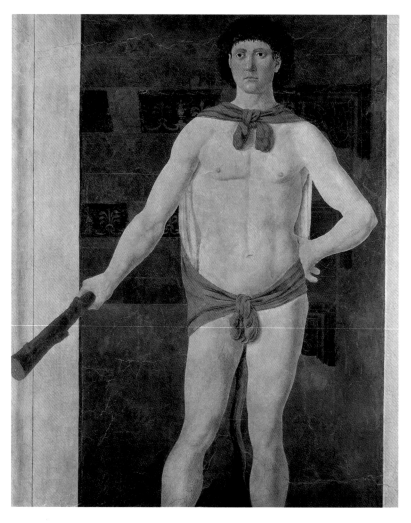

Piero della Francesca, *Hercules*

Overleaf: The Early Italian Room

as a single, self-contained image. The *Hercules* was cut off below the knees by Piero's descendants to make space for a doorway. Piero presents the figure frontally before a temple, with little ornamental design or references to his identity or exploits (just his club and lion pelt) to detract from his noble, brooding presence. Rather than weigh down his subject with archaeological trappings, Piero creates a figure of passive but monumental and enduring force and conviction.

Isabella Gardner's purchase of the fresco proved to be a labor worthy of Hercules himself, and the correspondence regarding the acquisition encompasses the years 1903 to 1908. Cavaliere Giovanni Battista Collacchioni, a descendant of the artist, sold the work to a Florentine dealer in 1903 to fund his ambitions as an opera impresario. Although Gardner purchased the fresco that winter, appeals to prevent its export from Italy delayed its removal for three years. The fresco was finally shipped in late 1906 to Paris and then to England, where it and other purchases sat for another three years. The regressive American customs regulations for the importation of art works resulted in a final and costly turn of events. Only in 1909, after, according to newspaper accounts, Gardner paid $150,000 taxes on purchases totaling $80,000, were the art objects released to her. As one sympathetic Boston paper commented,

The law of this republic is very strict with all misguided persons who dare to bring to this land paintings, or statuary, or valuable works of research. What these persons should do, if they wish to be favorably regarded by the law, is import dogs. A snarling, bleary-eyed bulldog of uncertain walk and disagreeable temper, valued at $10,000, can be imported free of duty. A yelping, howling, snapping poodle, of no earthly good to himself or humanity, but valued at $8000, can be imported duty free. An obese, ungainly and repulsive dachshund of a value of $5000 can be imported duty free. . . . But any millionaire who tries to import works by Titian, Rubens, or Turner, is lucky if he escapes jail.

The tax and penalties severely limited Gardner's ability to purchase art for the next several years, as subsequently did World War I and her stroke in 1919. One can only speculate whether she would otherwise have purchased works offered to her during this period that she might have been able to afford (including Giovanni Bellini's *Feast of the Gods*, now at the National Gallery of Art) had she not been so overwhelmingly taxed. To add insult to injury, within a year of her payment, the luxury tax on the importation of art works was removed, largely as a result of her lobbying in concert with J. P. Morgan.

Beneath the Piero fresco and on the wall opposite the portal are two long, narrow panel paintings, each featuring an allegorical subject. The

paintings were originally the decorative front panels of two wooden *cassoni,* chests in which prosperous Italian families stored valuable belongings. These Florentine panels, painted about 1450 by Francesco di Stefano (1422–1457), called Pesellino, were almost certainly commissioned in connection with a marriage. The bride's trousseau would have been placed in the cassoni and taken with her to the groom's house. The subjects of the two panels, **The Triumphs of Love, Chastity, and Death** and **The Triumphs of Fame, Time, and Eternity,** derive from verses from the epic poem *The Triumphs,* written by the early Florentine poet Petrarch between 1352 and his death in 1374. The first panel depicts Love on a ball of fire with his bow and arrow, with Chastity on the right on a chariot with Love (Cupid) bound. On the far right, Death advances steadily from the right toward this group. In the other panel, Fame, which overcomes Death, is seated in a glorious ring surrounded by the great figures of the arts and sciences, including Dante and Virgil, while Time approaches from the right. At the far left, Eternity is represented by God and his host over the world. A contemplation on love thus becomes a moral allegory. The illustrations are a wonderfully imaginative conflation of classical imagery and late medieval heraldic theater. From the fourteenth through the seventeenth centuries great processions with allegorical floats were commonly assembled in Florence on special occasions, including weddings.

One of the most beautiful altarpieces in the museum's collection is also one of the earliest: **The Madonna and Child with Saints Paul, Lucy, Catherine, and John the Baptist,** of about 1320, by the Sienese master Simone Martini (1283/85–1344), installed to the left of the portal leading to the Raphael Room. The painting, acquired by Isabella Gardner in 1899, is possibly the only complete polyptych (multipaneled altarpiece) by Simone in the United States. The four saints depicted are, from left to right, Paul, Lucy, Catherine, and John the Baptist. Surmounting the Virgin and Child is a victorious and blessing Christ, while on the pinnacles to either side angels hold symbols of the Passion and summon the Last Judgment with their trumpets. The altarpiece was probably made for the Church of San Francesco in Orvieto and is a paean to the golden age of Sienese painting. For pioneering Florentine painters like Giotto (see the Gothic Room), Simone's contemporary and only equal, or Giotto's immediate followers (such as Bernardo Daddi, whose **Madonna and Child with a Goldfinch** dates to the 1340s and was installed by Isabella Gardner in the Early Italian Room opposite the Simone), the exploration of the world of the senses to convey religious truths was expressed through simple, broad figures of dignity and weight that moved with

The Early Italian Room, east wall, with Simone Martini, *Madonna and Child with Saints Paul, Lucy, Catherine, and John the Baptist* (above), Pesellino, *The Triumphs of Love, Chastity, and Death,* and two eighteenth-century Venetian chairs

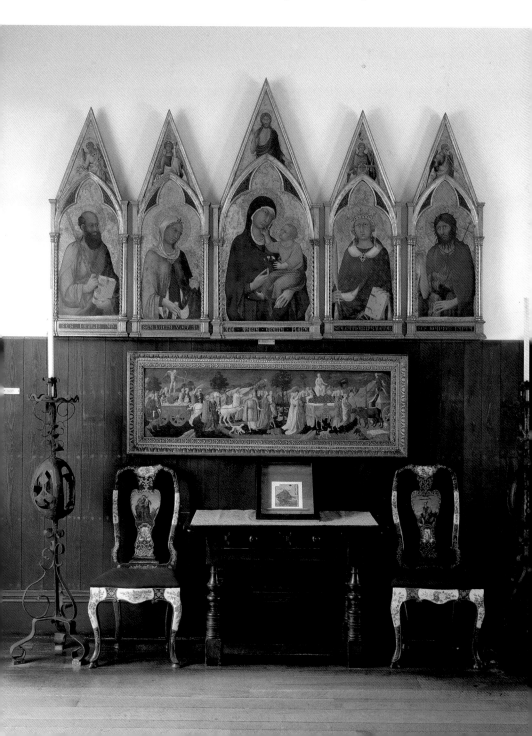

purpose and directness of sentiment. The style reflected the experience of an emerging consumer society in the prosperous Florentine middle class. But Simone de-emphasized mass to explore the lyrical, emotive power of flowing outline and shimmering, visionary colors. The infant Christ's robes are shaded through the audacious juxtaposition of primrose pink with lime green, and the Virgin's deep blue drapery frames her face, so gently chucked by her son, with an intricate embroidered hem applied in an elegant gilt patterning. Their tender intimacy is enhanced precisely by Simone's minimizing of their physical mass in favor of sentiment and brilliant color.

Ambrogio Lorenzetti was also a Sienese master of the early fourteenth century (active 1319–1347). In its lack of depth, delicately painted hands, and brilliant colors Lorenzetti's early **Saint Elizabeth of Hungary** reflects his Sienese origins. Giotto's influence is evident in the broad, even shading, firm outline, and round modeling of the saint's face. How the painting came into the Gardner collection is a poignant story. The American writer John Chapman and his wife visited Isabella Gardner in 1917, a year after their son, Victor Emmanuel, had died in combat in France. Several months later they sent the Lorenzetti to the museum as a gift. Gardner originally placed the painting within a wreath with a card that read "in memory of Victor Chapman," and she later placed it on an easel against a French chasuble (a priest's stole), the pattern of which picks up the floral elements within the basket St. Elizabeth holds.

The essential tenets of Sienese painting changed little from the fourteenth through the fifteenth centuries. In **The Child Jesus Disputing in the**

Bernardo Daddi, *Madonna and Child with a Goldfinch*

The Early Italian Room, view to the north, with Ambrogio Lorenzetti's
Saint Elizabeth of Hungary

Temple, a work of the early 1470s, Giovanni di Paolo (active by 1417,
died 1482/83) uses the traditional medium of tempera (pigment mixed in
egg white) to depict the youth in an artificially contracted space, with
Mary and Joseph being guided in from the left. The work, to the left of
the fireplace and in excellent condition, embodies the final stages of a
brilliant coloristic tradition.

Fra Angelico (ca. 1390/95–1455) joined the Dominican order in 1425
and was known among his contemporaries in Florence as Fra Giovanni

Giovanni di Paolo, *The Child Jesus
Disputing in the Temple*

da Fiesole. He was as renowned for his sweetness and purity of life as for
his artistic genius. The sixteenth-century biographer and artist Giorgio
Vasari wrote that he "was a simple man and most holy in his habits. . . .
He was most gentle and temperate, living chastely, removed from the
cares of the world. He would often say that whoever practiced art needed
a quiet life and freedom from care, and that he who occupied himself
with the things of Christ ought always to be with Christ . . . so humble
and modest in all his works and conversation, so fluent and devout in his
painting, the saints by his hand being more like those blessed beings than
those of any other. Some say that Fra Giovanni never took up his brush
without first making a prayer." By the early 1430s Fra Angelico was
already celebrated as an illustrator and painter. **The Burial and Assump-
tion of the Virgin,** datable to about 1432, is an early work by the artist
and was one of a series of four tabernacle paintings depicting the life of
the Virgin executed for the Dominican church of Santa Maria Novella in
Florence. A heavenly Christ, dramatically and masterfully foreshort-
ened, hovers in the uppermost zone, waiting to receive the Virgin, who
rises through his intercession, her light-tinted robes enhancing the sense
of her effortless ascent, in the central section, surrounded by pastel-
colored attendant angels. The angels about her head play musical instru-
ments. In the lower section, the Virgin lies on her bier, surrounded by the
disciples, individually responding in grief and contemplation, Peter offi-
ciating while John, at the other end, holds a triumphant palm. A symbolic
Christ stands at center holding a child that represents Mary's soul. The
painting is animated not only by the fresh, lyrical colors but also by the
artist's masterful gilding. Whereas the bier linens are intricately tooled to
convey the weight and texture of sumptuous fabric, the heavenly realm of

the middle zone is differentiated as an extratemporal space by the absence of detailing in the gilt background, and in the upper zone, the spiritual being of Christ and his host are suggested by the barest gilt outline. Isabella Gardner placed the work in a favored location, by the window, to capture the natural light.

In its own case on a table beneath the Simone Martini altarpiece is an image of a courtier, **A Portrait of a Seated Turkish Scribe or Artist.** The work is by the fifteenth-century Venetian painter Gentile Bellini (ca. 1430–1507). The Arabic inscription is apparently an erroneous transcription of a Greek version of the name Bellini. Gentile was the elder brother of the great Venetian painter Giovanni Bellini and son of the artist Jacopo Bellini, for whom he worked and whose studio he inherited. In 1479, Gentile was sent by the Venetian Republic to Constantinople, where he remained until November 1480. He is recorded to have painted many works for the Turkish court, including a portrait of the sultan. A traditional Venetian taste for colorism and evoking textures enlivens his work. The Gardner portrait is infused with a Venetian sensitivity to light and shadow, evident in the rendering of the subject's face, hands, table, and subtly modeled turban, and it displays a European appreciation of mass and volume. The artist follows Eastern profile and design conven-

Fra Angelico, *The Burial and Assumption of the Virgin*

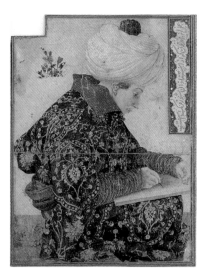

Gentile Bellini, *A Portrait of a Seated Turkish Scribe or Artist*

tions, especially appreciating color and rich patternings, which would attract a Venetian.

Amid such paintings, it is easy to overlook the museum's furnishings, but they contribute fundamentally to the character of the spaces and intimacy of the rooms. More than four hundred and fifty pieces of historic furniture are housed in the Gardner Museum. These include, in this room, a "set" of twelve **Venetian chairs,** datable to about 1730. Their design is influenced by Queen Anne–style furniture in England and slightly earlier Dutch models. Each chair has a different image on its central splat, and although the same colors of highlighting and patterning are used in each chair, the specific patterning varies. It is possible that the chairs, which feature narratives—several with classically attired young men and women, several with faddish Turkish costumes and motifs, others in fantasized Chinese modes (commonly known as chinoiserie) —came from a single studio production. The chairs may constitute a composite group from several related but distinct series.

The Raphael Room

The first major public room that one enters in Fenway Court, the focal space of the *piano nobile* of Isabella Gardner's palace on the Fenway, is, appropriately, the Raphael Room. For just as this room opens out dramatically from the smaller and darker Early Italian Room, so its art treasures of the sixteenth century bespeak the culmination of artistic aspirations expressed in the Trecento and Quattrocento. And as the Titian Room above the Raphael Room celebrates the authority of the

golden age of Venetian painting, so the Raphael Room is dominated by the achievements of central Italy. Together with Leonardo, Michelangelo, Giorgione, and Titian, Raphael (1483–1520) defined the stylistic ideals of a classic age and was the most highly esteemed of these masters in the Victorian era. Isabella Gardner was the first American to acquire and bring Raphael to American shores, and she was able to represent his genius with three works—an exquisite religious piece from his youth, a bold and sophisticated portrait from his maturity, and a remarkable late colored-chalk drawing, preparatory for a Vatican fresco. Although the Raphael Room also contains a major late work by Botticelli and other notable art works, it is Raphael's portrait of the portly **Count Tommaso Inghirami**, to the left on the opposite wall, that first catches the viewer's eye on entering the crimson-upholstered room.

Tommaso Inghirami was born in Volterra in 1470 and died in Rome in 1516. When Tommaso was just two, his father was killed. He became a ward of Lorenzo de' Medici, who brought him to Florence and had him well educated. By age thirteen, Inghirami had traveled to Rome, where he rose in the Church owing to his intelligence and wit and his prominent Medici patronage. While a young man Inghirami was sent by Pope Alexander VI to Milan as a nuncio to the Emperor Maximilian, who created him a count palatine. He was appointed a canon of Saint Peter's, as indicated in the portrait by his red robe, and his personal charm, wit, and poetic talents kept him in the good graces of successive Borgia, della Rovere, and Medici popes. Julius II appointed him chief librarian of the Vatican, secretary to the Lateran Council (1512), and secretary to the College of Cardinals. In the court of Leo X de' Medici, Inghirami exploited his talents in classical scholarship, statecraft, and theater. He wrote plays, executed theater designs, and once, when the sets in a production of a play collapsed, entertained the audience extemporaneously with amusing Latin verse. He was also a popular preacher. Inghirami features prominently, his portrait somewhat idealized, in the left foreground in Raphael's *School of Athens*.

In creating a likeness of this popular and influential figure, Raphael, the greatest portraitist of the Italian High Renaissance, faced an overwhelming dilemma: the subject's homeliness, for Inghirami was obese and suffered from the disfigurement of strabismus, an impairment of the eye muscles. These limitations inspired Raphael to one of his most remarkable compositional conceits. He presents the canon's broad form with simple dignity and great monumentality in brick red against a

Overleaf: The Raphael Room

simple, dark background. Just enough objects surround Inghirami to convey the sense that we are seeing him in his study and to underscore the turn of his body. The torso becomes in effect a base for presenting the activated face of the subject. Yet rather than appearing as a stolid block, the lower torso suggests motion by its rotation in space, complementing the active hands and upturned face. The composition focuses the viewer's attention on the dominant expressions of Inghirami's personality—his writing hand and active mind. Inghirami is shown as though taking dictation from the pope or a papal council, his weak eye brilliantly exploited. Turned and raised upward, the eye seems to gaze up and off to the left in a pose of inspiration that is reminiscent of ancient depictions of the evangelists inspired by an angel or an eagle and in turn appropriated from images of classical writers inspired by muses. The nature of the reference and its antique source make the pose even more appropriate. The canon's massive form seems charged with energy and intelligence. Another version of the portrait exists in the Pitti Palace in Florence, and surface loss to the Gardner painting complicates judgments on precedence, but the Gardner version appears to be a replica by Raphael and his studio.

Gardner was not satisfied with the triumph of acquiring one Raphael and continued, unsuccessfully, to search for a Madonna. This pursuit, however, was not so single-minded as to prevent her in 1900 from acquiring an early Raphael of tender delicacy, bearing all of the sweetness, the *dolcezza*, of Raphael's native Umbrian school and of his early master, Perugino. The little **Pietà** once formed the right narrative predella (a lower, smaller panel) to a large composite altarpiece Raphael executed for a church in Perugia about 1501–1502. The composition, which reflects Raphael's style before his move to Florence in 1504, is one of refined lyricism, the supine body of the dead Christ modeled with delicacy. Nicodemus and Joseph of Arimathea frame the central group while John the Evangelist and Mary Magdalene draw the viewer's eye from left to right. Unifying the intimate composition is the restrained palette of green, blue, and red, which carries the viewer rhythmically across the picture plane. The softly modeled figures are embraced by the atmospheric blue landscape that gently curves toward the central lamentation group. Raphael, inspired by Perugino and narrow relief sculptures of antiquity, has placed all of the figures in one slightly recessed plane. As Bernard Berenson wrote, "The subject scarcely could have been treated in a gentler, more hushed, deeper spirit. The almost boyish touch has the greatest fascination." The work was composed by a youth less than twenty years old.

To the right of the Raphael portrait Gardner placed the jewel-like

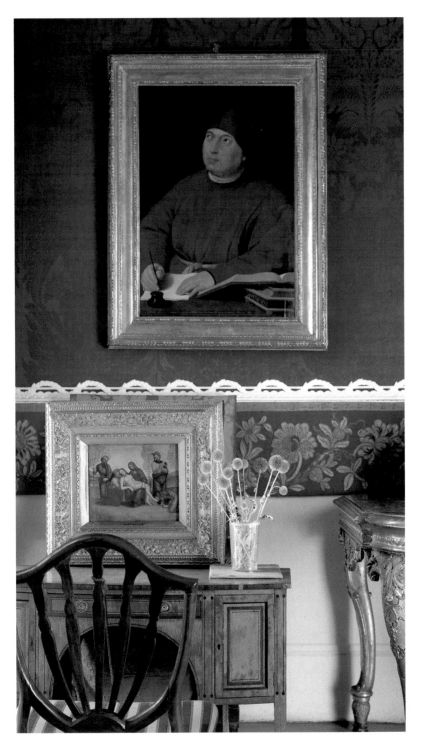

Raphael and Studio, *Count Tommaso Inghirami* (above) and Raphael's *Pietà* (below)

panel **Saint George and the Dragon,** by Carlo Crivelli (ca. 1430–1495). Born and trained in Venice, Crivelli left the city after serving a brief prison sentence in 1457 for abducting a sailor's wife. The Gardner painting is one panel of a multi-paneled altarpiece of 1470, dispersed in the nineteenth century, for the church in the small town of Porto San Giorgio, near Fermo, on the Adriatic. The donor was an Albanian named Giorgio Salvadori. The patron figure of Saint George was thus meaningful to church, town, and donor. The legendary saint and martyr was said to have been a Roman soldier of the fourth century. By the late Middle Ages Saint George was favored as a patron by soldiers and sailors in the Adriatic. The depicted episode, the most famous from his life, shows him slaying a dragon that had demanded the sacrifice of a virgin from villagers. In typical Venetian Gothic fashion, the picture displays a relish for a pageantlike presentation of the young saint on his charger. Nonetheless, the work is remarkable for its orchestrated presentation of the exotic, lizardlike monster, the spiky castle and cliffs, the steepled medieval townscape, the formal geometric gardens and manicured trees, the glistening armor, and the rhythmic decorative patterning of figures. With its sumptuously designed, silhouettelike forms pressed to the surface, the composition recalls a glorious tapestry, an intricate sensual delight for the eye that certainly enthralled Crivelli's provincial patrons and audience.

On the opposite side of the portal hangs a work of great significance for the Gardner collection. Apart from its stature as an important late work by Sandro Botticelli (1444/45–1510), the **Tragedy of Lucretia** was Isabella Gardner's first major Italian painting, establishing the direction and desired quality of future acquisitions. It was also the first bought through the agency of the young Bernard Berenson, who acquired it in 1894. The *Tragedy of Lucretia* was probably commissioned to hang in the house of Giovanni Vespucci, the son of the highest public officer of the Florentine Republic, and depicts episodes from Livy's *Lives*. As Livy recounts the legend, in the sixth century B.C., during a military campaign in the reign of the tyrant Tarquinius Superbus, Collantinus praised the chastity and virtue of his wife, Lucretia, and the officers decided to bet on their wives' virtue. Secretly returning to Rome, they discovered that only the lovely Lucretia was demurely spinning with her female servants—the other wives were amusing themselves. Sextus, the son of Tarquinius Superbus, was aroused by Lucretia's beauty, however, and attacked her during her husband's absence. When she resisted his advances, he threatened to kill her and one of his slaves and place their naked bodies together, claiming that he had punished them for committing adultery.

Carlo Crivelli, *Saint George
and the Dragon*

Thus threatened, Lucretia succumbed. Botticelli has depicted this moment at the left of the panel, setting the attack outdoors. The following day, Lucretia summoned Collantinus and her father, told them what had happened, and stabbed herself, so that, as Livy records, "Never shall Lucretia provide a precedent for unchaste women," depicted at right. At the funeral, Junius Brutus's oration, shown at center, incited a popular rebellion that overthrew the monarchy and founded the Roman republic. Botticelli has taken liberties with Livy's narrative in order to present the three incidents simultaneously in a stagelike classical exterior modeled on the descriptions of unified architectural settings of Roman tragedy. The theatrical gestures of the dramatis personae complement the setting.

The *Tragedy of Lucretia* was intended to convey a clear political message. When Botticelli completed the painting (approximately 1504), the Florentine populace had recently overthrown the "tyranny" of the Medici. After the death of Lorenzo the Magnificent in 1492 and the consequent excesses of his son, Piero, a republic had been established, originally under the leadership of the Dominican preaching friar Savonarola (1494), and the symbolic relevance of the tragedy of Lucretia was obvious. The stories of Lucretia and Virginia (the virtuous subject of

Sandro Botticelli, *Tragedy of Lucretia*, in situ

the companion panel by Botticelli, now in Bergamo) were also appropri-
ate matrimonial themes for the patron, Vespucci having married in 1500.
The painting contains other references to ancient Roman virtue and
valor, as well as Old Testament examples of individuals overcoming
tyranny against overwhelming odds. Notable among these are the figure
of David at center atop a Corinthian porphyry column and an image of
Judith with the head of Holofernes on the building relief at left. After the
fall of the Medici, Donatello's *David* and *Judith and Holofernes* had
been removed from the Palazzo Medici and placed in the courtyard of the
city hall, the Palazzo della Signoria. And in 1504, Botticelli was on a
commission established to decide where to place Michelangelo's newly
completed statue of *David*.

Botticelli has presented this complex narrative with great personal
commitment and painterly care. The grieving figures are portrayed with
individuality and poignancy. Restoration has wrought important changes
in the panel's appearance: highlighting with gold dust has been revealed,
delicate shading and reflected light have re-emerged, as in the monument
arches, the richly patterned leggings of the soldiers have reacquired their
brilliance, and the lifeless head of Lucretia is touchingly distinguished
from other depictions of her in the panel. The buildings are shown to

have been carefully incised into the gesso under the paint, and the underpainting of a head, possibly a self-portrait, has been discovered to the right of the grieving man in the gold-yellow cloak at the center.

Opposite the Botticelli is one of the most intriguing paintings in the collection, whose creator, for lack of firm attribution, was dubbed the Master of the Gardner Annunciation. The **Annunciation** dates to about 1475, and has been attributed to Umbrian, Florentine, and even Roman artists. It is most likely attributable to Piermatteo d'Amelia (active 1467–1502), an Umbrian artist influenced by Verrocchio and Florentine painting whose style has affinity with the young Perugino. The Virgin is shown at prayer being approached by the archangel Gabriel, who bears a lily, while the dove of the Holy Spirit descends on a gilt beam of light. The composition is set within the central court of a Renaissance palazzo, geometrically laid out with great simplicity, the vaulted passageway behind and between the figures, the lines of perspective and especially the tiled floor guiding the eye back to a beautiful landscape beyond the walls. At the center of the revealed landscape stands a verdant tree, probably symbolic of the Tree of Wisdom.

How Bernard Berenson and Isabella Gardner acquired the painting is a remarkable story. The painting had decorated the outside wall of the Porziuncula, a chapel of Saint Francis enclosed within a sixteenth-century church, Santa Maria degli Angeli, below Assisi. Berenson claimed that the painting had been the property of a monk. It had disappeared from the church in the late nineteenth century, reclaimed by the monastery that had title to it and recognized its value. It subsequently turned up in the "workshop" of a dealer who dealt both in originals and in fakes based on them. Berenson's wife, Mary, tracked it down there and got to

Sandro Botticelli, *Tragedy of Lucretia*. Photo: Clive Russ

Piermatteo d'Amelia,
Annunciation

it, as she noted, "just in time to save it," because the panel was splitting. Although there is no correspondence to Isabella Gardner on the subject, Mary Berenson later wrote to her mother that she had a special trunk prepared for it, with a separate compartment for the painting that was covered by dolls to avoid any "complications" with customs.

Just to the right of the door as one enters the room, Isabella Gardner placed a striking profile portrait by Piero del Pollaiuolo (1443?–1496), **A Woman in Green and Crimson,** energized and given character and vivacity by its fluid contour line. The portrait, also attributed to Pollaiuolo's elder brother, Antonio (1432–1498), reflects a contemporary Florentine convention of half-length profile portraits, an image-type derived from earlier traditions of medals and donor images. The portraits proliferated among an urban gentry that sought to commemorate family members by invoking prototypes associated with antiquity and the nobility. By depicting sitters in domestic attire and unspecified settings, however, the Florentines established a virtuous republican context. Such ennobled likenesses of socially prominent Florentines were intended to convey an enduring *virtù.* The Pollaiuolo portrait marks an interesting extension of the type into a more personal, less ennobled direction. The sitter's dress and profile are notably unpretentious. The rhythmically conveyed vitality of the picture suggests that it dates to the last quarter of the fifteenth century. It is as if the convention of the simple profile portrait was straining to encompass a more spontaneous and dynamic means of conveying individuality consonant with the aesthetics of a new generation.

To the left of the door as one enters the Raphael Room hangs the **Madonna and Child with a Swallow,** a work of about 1440–1450 by Pesellino. This picture seems to have enjoyed great immediate popularity in Florence, as indicated by the many surviving contemporary variations of the work, none by Pesellino. The broad, softly modeled figures and

classicist marble niche setting show the influence of the contemporary Florentine painter Fra Filippo Lippi (ca. 1406–1469) and the lyrical colorism of Fra Angelico. The picture is a private devotional panel. The infant Christ confronts the beholder as he grasps the barn swallow, poignant symbol of the Resurrection. The Madonna, resembling a noble classical matron, seems lost in thought, meditating on the sorrows, also indicated by her red robe, that her son must endure for humanity's salvation. It is an image of intimate appeal and utmost piety.

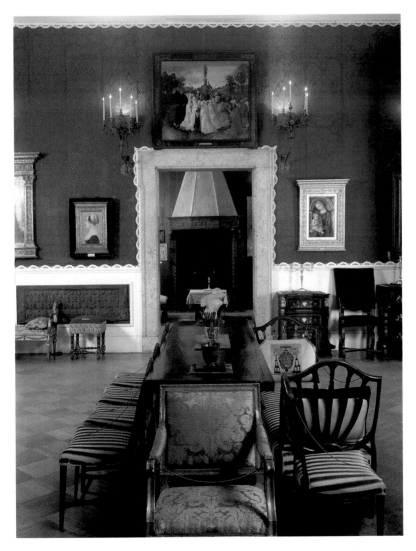

View into the Early Italian Room

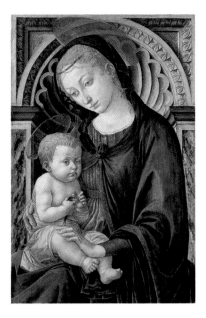

Piero del Pollaiuolo, *A Woman
in Green and Crimson*.
Photo: Clive Russ

Pesellino, *Madonna and Child
with a Swallow*

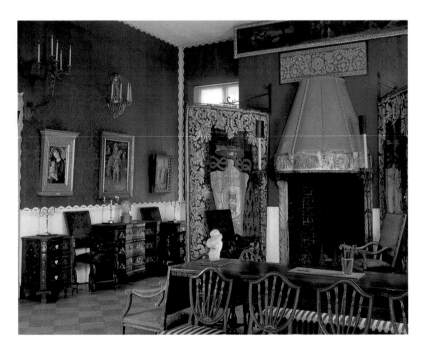

The Raphael Room, northwest corner

From the Raphael Room one enters the Short Gallery, a corridor linking the front rooms with the Tapestry Room and the galleries opposite the courtyard. In this short space Isabella Gardner placed works with a personal association, including portraits of herself, her husband, and her ancestors, as well as several interesting pieces of porcelain and her small collection of prints and drawings.

Undoubtedly the most vivid of the many portraits of Isabella Stewart Gardner is one that is linked with a charming story about her, **Mrs. Gardner in Venice,** by Anders Zorn. In 1894 the Gardners took up a late summer and autumn residence in Venice in the Palazzo Barbaro, overlooking the Grand Canal. Among their visitors were the Swedish Impressionist artist Anders Zorn, whom Isabella Gardner had sponsored in the United States, and his wife. According to Jack Gardner's diary, on the evening of October 20, the Gardners, the Zorns, and others were listening to an after-dinner concert in the palazzo when Isabella Gardner went to the balcony during a fireworks display. Opening the glass doors, she turned back to the company "and stood in the archway, arms outstretched. 'Come out—all of you,' she cried. 'This is too beautiful to miss.' " The artist, inspired by the moment, the figure of his hostess and patron dramatically lit by the artificial light inside and the fireworks beyond, over the darkened waters of the Grand Canal, captured Gardner's energetic spirit in this oil sketch. He largely completed it in two days—though he continued to fuss over it for some time thereafter. The loose brushwork of the sketch gives Isabella Gardner's long citron gown the effect of a magnificent flame by night, as if she herself were the source of light. The shimmering highlights of the distant fireworks and crimson flowers on the carpet in the foreground, like burning embers about her radiant figure, create a sensation of a captured moment and an unforgettable image as much of Gardner's spirit as her physical being. In her fingers pressed to the glass doors, assertively opening out to the world of Venice beyond, her figure striding forth, and her eyes making contact with the viewer, Isabella Gardner's unassailable will and vision are affirmed. And Zorn did not fail to include her long strand of pearls with ruby pendant, appropriated by Henry James in his description of Milly Theale in *The Wings of the Dove.*

To the left of the Zorn oil sketch, over the cabinet, is a portrait of **John Lowell Gardner** (Jack), dating to 1895, by the most prominent Italian artist of his time, Antonio Mancini (1852–1930). A portrait of Isabella

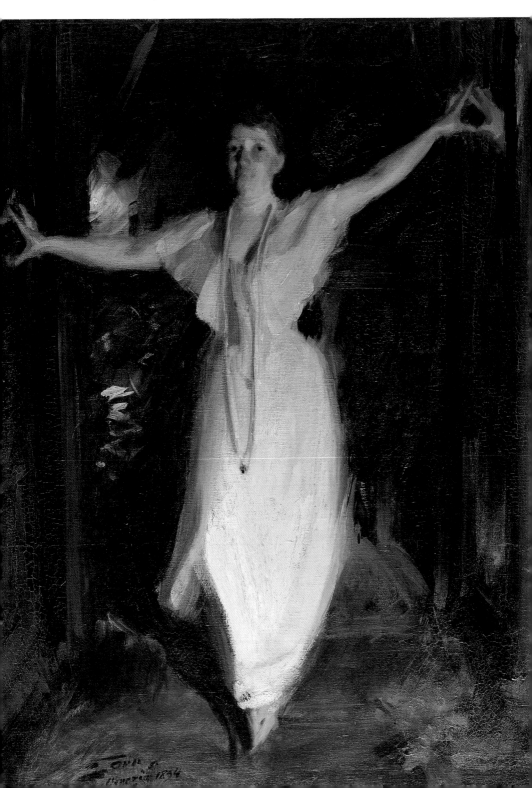

Anders Zorn, *Mrs. Gardner in Venice*. Photo: Clive Russ

Gardner's beloved grandmother, Isabella Tod Stewart, by Thomas Sully (1783–1872), dating to 1837, hangs opposite.

In front of the window Isabella Gardner placed an easel with a single drawing: **A Gondolier,** from the workshop of Vittore Carpaccio (1460/65–ca. 1526), a study related to a painting dating to 1494, executed in brush and brown ink with white gouache on blue-green paper. In its subject matter, sense of atmosphere, color, and texture, and use of multiple media and colored paper, the study is typically Venetian.

To the right, beyond the doors to the Little Salon, are the wooden cabinet cases Isabella Gardner designed to contain many of her prints and drawings. In the first cabinet are her most important European acquisitions. She did not seek to amass a substantial number and did not think of herself as a collector of drawings. Her drawings, both purchased and gifts, were a complement to her collection of paintings. She acquired her Italian drawings at an auction in May 1902. On the face of the first cabinet is a pen and brown ink drawing **The Young Christ and Saint John the Baptist Embracing,** by the Florentine artist Filippino Lippi (1457/58–1504). This sheet is typical of Filippino's mature animated, nervous drawing style. The figures' contours and drapery are sharply and clearly defined in assertive, rapid pen strokes.

Antonio Mancini,
John Lowell Gardner

Workshop of Vittore Carpaccio,
A Gondolier

Filippino Lippi, *The Young Christ and Saint John the Baptist Embracing*

Within the case are several of Isabella Gardner's most important drawings. Preeminent is the black chalk drawing of the **Pietà** by Michelangelo Buonarroti (1475–1564). Although as a draftsman Michelangelo is probably most famous for his preparatory chalk studies of the human figure and his pen-and-ink compositional and architectural sketches, he also executed a limited number of presentation drawings, finished art works created out of affection as gifts. Michelangelo presented this drawing to Vittoria Colonna, probably in the early 1540s, at her request. Colonna was the widow of an imperial general and a descendant of one of the oldest and noblest of Roman families. Devout and intelligent, she was a poet and one of the leading figures in the movement to reform the Church from within. Michelangelo became her close friend and admirer during the last years of her life, and they exchanged poems and many letters. On the upright beam of the Cross, Michelangelo inscribed a line

from Dante's *Paradiso,* translated, "No one thinks of how much blood it costs." The implication, of course, is precisely that the pious Colonna, like Michelangelo himself, does think of such matters. A crown of thorns is lightly delineated at Christ's feet. Clearly a meditational work, the drawing is executed with great care and effort, with soft modeling and atmospheric shading of the figures, less boldly sculptural than his more common figure studies.

Beneath the Michelangelo is a sheet of **Studies for Figures in "The Resurrection" Altarpiece,** by Angelo Bronzino (1503–1572). The altarpiece hangs in the Church of the Annunziata in Florence and was completed in 1552. The drawing is a study for the figure of a cuirassed soldier in the lower left, with a further sketch for the figure of an angel. Elegance of style and grace in pose and proportions dominate Bronzino's Mannerist concerns. The primary figure—who is witnessing Christ's rise from the tomb—seems balletically posed, his posture determined less by his response to the miracle than by the dictates of a courtly and stylized artistic convention.

Facing these drawings is a rare work by Raphael. **Pope Sylvester I Carried in the Sedia Gestatoria, with His Retinue,** is a late work, executed in red, orange-red, yellow, black, and white chalks on paper squared for transfer onto another sheet. The composition, reminiscent of sculptural relief and probably organized in the studio from draped models, is of the left half of a design for the decoration of the Sala di Constantino in the Vatican, a commission finished by Raphael's studio after the thirty-seven-year-old master's death in 1520. The use of mixed chalks is highly unusual for Raphael, most commonly found at the time among the followers of Leonardo in Milan. The method, with its loose, impressionistic handling of chalk, was used only once elsewhere by Raphael, in a portrait drawing of an ecclesiastic of the same period. The Gardner drawing depicts Pope Sylvester I (reigned 314–335) in the *sedia gestatoria* coming out to meet the Emperor Constantine.

The cabinet also contains nineteenth- and twentieth-century works, including prints and early drawings by Matisse. Like the painting *The Terrace, St. Tropez,* in the Yellow Room, the drawings were the gift of Thomas Whittemore, an early patron of Matisse. The vibrant, aggressive **Savages,** drawn about 1900, anticipates Matisse's early Fauve work in its bold, intentionally crude, heavily worked pen style. A fluid, elegant, and sensual pen-and-ink line characterizes his **Three Girl's Heads, Tangier,** executed in 1912. The subtlest inflections and fluctuations of the flow and width of contour line masterfully convey mass and volume. Interspersed among the cabinets are other drawings, including works by Jean-

Michelangelo, *Pietà*

Agnolo Bronzino, *Studies for Figures in "The Resurrection" Altarpiece*

Raphael, *Pope Sylvester I Carried in the Sedia Gestatoria, with His Retinue*

Henri Matisse, *Three Girl's
Heads, Tangier*

Auguste-Dominique Ingres and Degas. The cabinets also store the bulk
of Gardner's collection of prints by Whistler and Zorn.

To enter the Little Salon is in a very real sense to enter another century
or, rather, other centuries, for it represents the mid-eighteenth century
and the Rococo as envisioned in the late nineteenth century. Although
Isabella Gardner selected her furnishings, boiserie (woodwork), paint-
ings, and decorative objects with great sophistication, to create an en-
semble that was as much a source of ambiance as a unified collection, she
did so with the outlook of her times. The choice of upholstery and
crowded placement of objects reflect aesthetics distinct from those of
eighteenth-century France and Venice, from which much of the interior
originates. Nonetheless, the overall feeling of this intimate room is re-
markably true to the individualistic spirit of an eighteenth-century pri-
vate salon, with its sensitive interplay of Rococo objects with those of
East Asia, its whimsy, and its color selections. The large eighteenth-
century mirror between the windows is Venetian, and carved into the
ornate wooden framing is the coat of arms of the Morosini, an ancient
family in the Serenissima that gave the city several doges. The mirror,
whose design reflects Louis XV models of mid-century, originated in the
Palazzo Morosini on the Ponte San Cancino in Venice.

Isabella Gardner placed four tapestries of **Gardens with Figures** along
the walls. They come from the Barberini collection, one of the great
Roman collections of the late sixteenth and seventeenth centuries, and
were acquired by her in 1903. Two are Flemish and date to about 1585–
1600. The Flemish works depict aristocratic figures in period costumes.

The other two tapestries were executed in Paris between 1625 and 1650. All feature a pergola with a central arch that serves as a screen about which the figures move and beyond which stretch formal gardens and grand houses in the distance. These courtship scenes include **A Musical Party, Strolling and Seated Lovers, Boating and Hunting Parties,** and a particularly delightful fourth scene of **Surprise Water Jets.** This tapestry depicts a humorous feature of Italian seventeenth-century gardens: hidden levers—in this case set off by the figure in the left foreground—that produce jets of water to surprise unsuspecting strollers, here the woman at right being helped by her companion from the edge of the fountain pool that has so suddenly become active.

Although Isabella Gardner's collection of eighteenth-century paintings is limited, it does include a work by a central figure of eighteenth-century French painting, François Boucher (1703–1770). Boucher was the favored painter of Louis XV and, perhaps equally important, of his mistress, the marquise de Pompadour. It was through Mme de Pompadour that Boucher came to the king's attention. **The Car of Venus,** a boudoir painting, with its loose brushwork and pastel palette of pink and

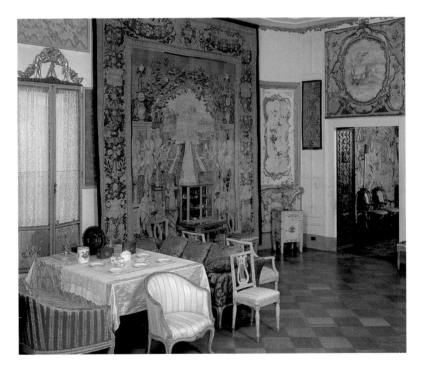

The Little Salon, view to the southeast, with the French tapestry
Surprise Water Jets
Overleaf: The Little Salon

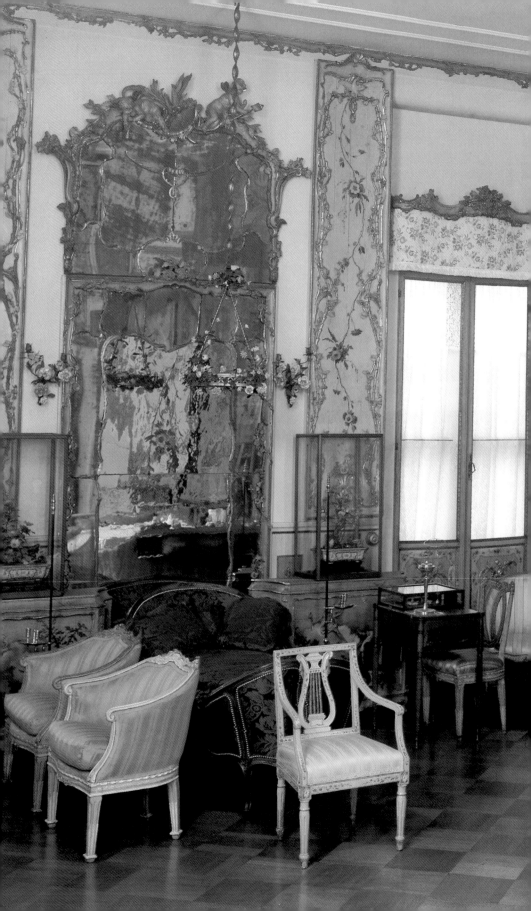

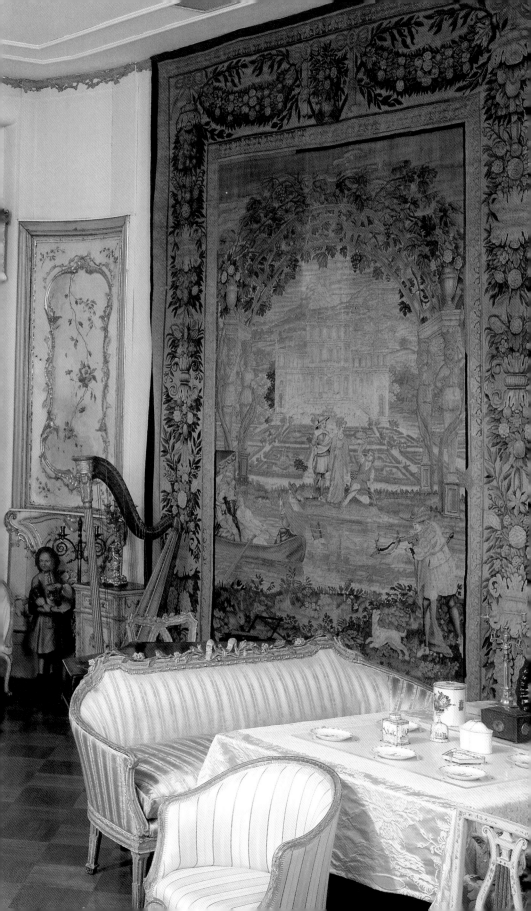

blue, converts the grand compositional effects of Titian and Rubens into the confection of daydreams. Cupids cascade down from the swan-drawn chariot through the heavens in which lovebirds hover, bearing torches and floral crowns of love. The work is on the wall to the left as one enters the room.

The Little Salon is furnished with a fine late eighteenth-century Venetian daybed, over which is suspended a Venetian lamp of the same period, and French furniture dating from about 1780, reflecting in the simpler lines of the legs the transition from Rococo to Neoclassicism. The

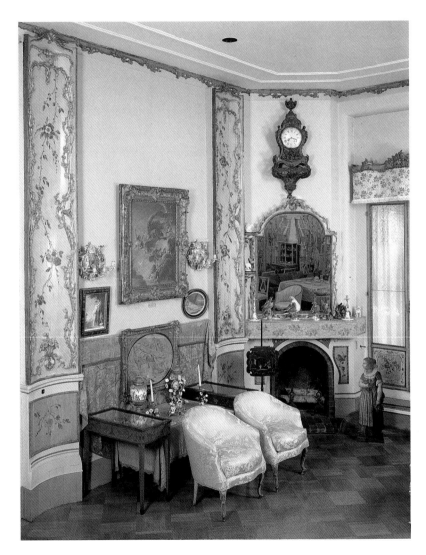

The Little Salon, view toward François Boucher, *The Car of Venus* (left)

room features two dummy boards. These painted boards of small male or female figures, sometimes dressed as servants carrying props, enlivened rooms, whimsically providing companionship—admittedly rather silent companionship—and delighting visitors. Dummy boards were first produced in England and the Netherlands in the late seventeenth century, and the custom persisted into the nineteenth century. The young boy holding a cat dates to about 1700. The companion young girl is of nineteenth-century manufacture. The various vitrines, cabinets, and tabletops in the room contain a broad range of eighteenth- and nineteenth-century bibelots.

The Tapestry Room

The Tapestry Room is entered through sixteenth-century Spanish doors ornamented with earlier Moorish nails. The fenestration includes Spanish Gothic arched stonework of the fourteenth and fifteenth centuries. Isabella Gardner opened the room to the public in 1915, creating it and the Spanish Cloister out of what had been the Music Room. The space resembles a Gothic great hall, and its name derives from two monumental series of tapestries, five works in each, hung around the room and purchased in 1905 and 1906. The tapestries were woven in Brussels during the mid-sixteenth century. At that time, Flanders was the center for tapestry manufacture. Artist-designers would supply cartoons (complete colored drawings for reproduction), which the weavers would set up on their looms, in the process reversing the design. One set, **Scenes from the Life of Cyrus the Great,** was formerly known as the Archduke Albert and Archduchess Isabella Series (a portrait of the archduchess by Frans Pourbus II is located in the Dutch Room). The other set, **Scenes from the Life of Abraham,** can be traced to the collection of Cardinal Francesco Barberini (1597–1679) in Rome and was still in the collection of the Princess Barberini in 1900. The *Cyrus* set, executed in wool and silk, features figures in costumes of the period of Emperor Charles V, then ruler of the Netherlands (note that Cyrus, founder of the Persian Empire, here resembles a Hapsburg), enacting stories of Cyrus's life as related by Herodotus.

Along the east wall on an easel by the block of four windows is a painting of **Santa Engracia,** by Bartolomé Bermejo (active by 1468, died

Overleaf: The Tapestry Room, with Pedro García de Benabarre's
Saint Michael over the fireplace

after 1495), dating to about 1474, executed for a church in Daroca, a once prosperous town in Aragon. Engracia was martyred at Saragossa under the Emperor Diocletian in A.D. 304, and her relics were found there in 1389. The brilliant colors and rich surface detail in this oil painting with gilt on wood are influenced by Netherlandish artists of the period. Bermejo is arguably the most important Spanish artist of his time, and this is one of just three works by the artist in the United States.

On a table along the wall to the right as one enters the Tapestry Room are six pages of **Arabic illustrated texts** of diverse stylistic origins, including Mongol, Persian, and Mesopotamian, dating from the thirteenth, fourteenth, and fifteenth centuries. The largest, **Water Clock and Musicians Before a Gate,** comes from a fourteenth-century book of *Automata,* dated 1354 and probably from Cairo. The water moves the figure from left to right on the parapet, causing a ball to drop at hourly intervals into

Arabic miniature illustrating a candle-clock

Bartolomé Bermejo, *Santa Engracia*

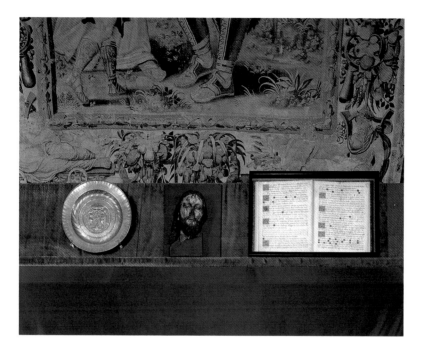

Isabella Gardner's table installation depicting the fall, redemption, and
salvation of humanity

the bowl beneath the falcon. The mechanical musicians are associated
with the clock because they sounded the hour. Another drawing from the
same book of *Automata* shows a **Candle-Clock,** in which the burning
candle releases metal balls that empty into the sling that extends from the
swordsman's arm, causing him to drop the sword to retrim the wick. The
ball then falls into the falcon at the base, which emits it, indicating that an
hour has passed.

The Near the easel along the west wall is a table covered with burgundy
velvet and satin. On it is a brass Nuremberg plate, possibly dating from as
early as the late fifteenth century, depicting the **Temptation of Adam and
Eve** (one of six such plates in the room). Next to the plate Gardner placed
a **Head of Christ,** German or Franco-Flemish, dating to the second half of
the fifteenth century, and a beautiful illuminated **Mass book** that was
created for Clement VII de' Medici (pope 1523–1534), opened to the
offering of the sacrament. Gardner thereby presents the Fall, redemption
through Christ's sacrifice, and salvation through the Mass.

The stone fireplace at the end of the room is French Gothic; it has been
dated to the fourteenth century and is partially restored. The center bears
the royal emblem of France, and the sculptor has carved a wonderful
menagerie of monkeys and other animals. Over the fireplace Isabella

Gardner set the chilling gold and tempera panel of **Saint Michael,** dated about 1450, attributed to the Spanish artist Pedro García de Benabarre (active second half of the fifteenth century). The archangel in his gilt-studded armor is shown trampling Satan, over whom he holds a spear. He also holds a balance for weighing souls. The work was created in the province of Huesca, then in Catalonia, and reflects contemporary currents of the International Gothic style in its sumptuous colorism, richly detailed courtly attire, and embossing, gilding, and studding.

The Dutch Room

The Dutch Room embraces several of Isabella Gardner's greatest triumphs and the museum's greatest misfortune. In this room Gardner placed one of her proudest purchases, *The Concert,* by Jan Vermeer (1632–1675), and it was in this room that she entertained on important occasions. Sadly, the room also recalls a tragic event in the history of Fenway Court. On the night of March 18, 1990, thieves dressed as Boston police officers gained entrance to the museum and stole thirteen works of art, the most celebrated and valuable coming from this room. Among the stolen works, which included the unique Rembrandt seascape, *The Storm on the Sea of Galilee,* as well as a double portrait attributed to Rembrandt, *The Concert* held a special place in the collection. Normally placed on the small table by the window to the right as one enters the room from the stairway hall, the painting captures the enchanting mystery of human relationships that is at the heart of Vermeer's distinct genius.

In **The Concert,** which dates to about 1658–1660, the Delft artist has provided just enough narrative to suggest unanswerable dramatic questions. The ambivalent gestures of figures turned from the viewer and ambiguity of their seemingly poignant relationships contrast with the accessibility of their bourgeois setting and the apparent clarity of their musical activity. This incongruity is enhanced by Vermeer's placement on the wall behind the figures at center and right of an actual painting by Dirck van Baburen, *The Procuress* (Museum of Fine Arts, Boston). Gentle landscapes are depicted behind the keyboard player and on the clavichord, enhancing the psychological tenor within the painting and eliciting the active participation of the viewer, who feels compelled to create an interpretation. The string instruments on the floor and the table, suggestive of love to the seventeenth-century viewer, frame the subjects, while the table instrument, a lute, guides the viewer's eye into the narrative. By the tilt of a head, the line of a brow, even the abjuring of defini-

tion, as in the case of the pivotal male instrumentalist with his back to the viewer, Vermeer has suggested his subjects' moods even when the precise context eludes us. He paints with seductive shimmering colors, caressing the jackets and gowns of the women, isolating their pearls, and exulting in the carpet beneath the instrument on the table. These glistening colors are disciplined by the delicately modulating gray-white light that streams in from the left, a light Vermeer understood in every nuance of softening shadow. The entirety he has set within the mathematically defined space of the room, with its gridlike floor patterns and carefully selected coloristic highlights of blue, citron, white, and orange.

Isabella Gardner purchased the painting under remarkable circumstances. Vermeer was an artist hardly known in the eighteenth and early nineteenth centuries. The painting was auctioned in Paris in December 1892, together with other works from the estate of the art critic Théophile Thoré, who had rescued the artist from obscurity. Isabella Gardner attended the auction, placing her handkerchief to her face to indicate to her agent when and how to bid. Amusingly, both the Louvre and the National Gallery in London were interested in the picture but withdrew from bidding, the representative for each gallery thinking he was raising the price for the other by bidding against the other. Only afterward did the bidders discover that Isabella Gardner of Boston had acquired the picture—and at a reasonable price.

On the wall immediately to the left as one enters the Dutch Room from the stairway hall (the opposite doorway if one is entering from the Tapestry Room) is a **Self-Portrait** by Rembrandt van Rijn (1609–1669), an early work of 1629. This painting is the first Rembrandt that Isabella Gardner acquired, and she later stated that it was this purchase that prompted her to create a museum collection. Rembrandt's production of self-portraits is without parallel in the history of European art. More than twenty etchings and sixty paintings of himself survive, many dating between 1628 and 1634, and his face appears in numerous other non-portrait works. Some psychological pressure, some need to penetrate his interior life through his artistic eye, must certainly have been behind Rembrandt's production of such a large corpus for which there would be minimal commercial demand. The images are hardly flattering. The early self-portraits tend to fall into two categories: studies of emotional ex-

Overleaf: The Dutch Room, *from left to right,* Frans Pourbus II, *Isabella Clara Eugenia, Archduchess of Austria,* sixteenth-century Bavarian, *Saint Martin and the Beggar,* Rembrandt van Rijn, *Self-Portrait,* and Albrecht Dürer, *A Man in a Fur Coat*

Jan Vermeer, *The Concert*

pression and direct, "passive" studies of his features. The fantastically attired Gardner *Self-Portrait* is Rembrandt's first of himself in what would be an exotic type he often used. In this portrait the twenty-year-old artist presents a trenchant, direct image of his face, with its bulbous nose and peering eyes. He wears the sumptuous ornaments, jewelry, and finery that he kept as studio props for creating the religious and historical paintings in which he also specialized. Yet, despite these trappings, Rembrandt's proletarian countenance dominates the work. He has set his eyes in shadow to draw the viewer psychologically into the composition to peer back at him, while creating highlights in his hair, the scarf, and elsewhere. Visible underpainting indicates that Rembrandt reworked the

composition, altering his profile and compressing the image to heighten its focused intensity.

The Storm on the Sea of Galilee, signed and dated 1633 (stolen in 1990), is a religious work created in this same early, highly dramatic vein. It is the first New Testament subject Rembrandt executed in Amsterdam and by far the largest history or religious painting he had executed until then. Rembrandt's depiction seems closest to the events described in Luke 8:22–25, when a storm has suddenly broken out and frightened the disciples, who in their anxiety have awakened Christ, who had fallen asleep during their crossing of the Sea of Galilee. Rebuking the wind,

Rembrandt van Rijn, *Self-Portrait*

Christ also rebukes the disciples for their lack of faith. The quiet calm of Christ, presented in soft highlight, contrasts with the frenzied expressions and activities of the disciples. Although the composition recalls a sixteenth-century print, Rembrandt invests the picture with the dramatic immediacy and natural terror that would attend such a moment. The storm sweeps the ship into a dramatic diagonal that is accentuated by light streaming in from the upper left, where a patch of blue sky penetrates the darkness. The turbulent water, rhythmic arrangement of figures, and lines of ship, mast, sails, and cables strikingly contrast nature's overwhelming force and human vulnerability. Rembrandt painted the figures on a small scale to underline this contrast, and amid the anxious crew he placed a self-portrait in the foreground, looking toward the viewer.

The Dutch Room is very much a room of personalities, inhabited not simply by a collection of portraits but by the individuals portrayed, the artists that portrayed them, and the mind that brought them together. Nowhere else in the Gardner Museum does so strong a sense of works in conversation with one another pervade a room. The daunting presence of **A Doctor of Law,** a work of about 1658–60 by Francisco de Zurbarán (1598–1664), confronts the viewer with a cold glance as one enters the room from the hallway. Zurbarán has depicted his subject in the doctoral robes of the foremost Spanish center of legal studies, the University of Salamanca. The painting is a rare example of Zurbarán's talent in formal portraiture. The subject is less the masklike visage or personality behind the robes than the robes—that is, the position—itself. Like Zurbarán's other late works, this painting reflects the influence of his contemporary, Diego Velázquez, whose broad, painterly application of color Zurbarán approaches here.

If one painting and two personalities can be said to dominate the Dutch Room, it is ironic that they should belong to a Flemish painter and an English subject. Peter Paul Rubens (1577–1640) was an extraordinary genius in an age of geniuses. Artist, courtier, diplomat, connoisseur and collector, classical scholar conversant in several languages, able teacher and businessman, devoted husband and father, Rubens dispatched some of the most renowned portraits, religious paintings, histories, mythologies, and landscapes of his century from his mansion house in Antwerp.

Rubens visited Charles I of England as an informal ambassador for Philip IV of Spain, arriving in June 1629 and departing the following March. Charles I was perhaps the greatest art collector of his age, and although Rubens was ostensibly in England in connection with commis-

Rembrandt van Rijn, *The Storm on the Sea of Galilee*

sions, he also was there to commence negotiations on peace terms between Spain and England. The sitter for this portrait was also a renowned collector. Thomas Howard, earl of Arundel (1585–1646), was descended from one of the most distinguished families in England; both his grandfather and later his grandson were dukes of Norfolk. He inherited the title earl marshal of England and had been created a knight of the garter by James I of England. Howard was hardly a military man, and his armor in this portrait is purely symbolic of his position as a marshal, indicated also by the baton he holds. He was, however, the creator of an

Francisco de Zurbarán,
A Doctor of Law

extraordinary collection of Greek and Roman sculpture, and he built an immense library. His wife, Alethea, who had sat for Rubens in Antwerp in 1620, was also a great collector of paintings. The earl's interests in antiquity and classical scholarship would have appealed to Rubens, who almost certainly began the painting about 1629. The perfunctory execution of the table at the right, the helmet, and the draperies indicate that the picture may not have been completed by Rubens. Its composition derives from a famous portrait by Titian, whom Rubens immensely admired and whose *Europa* he copied. Titian's inspiration is evident not only in the composition but also in the wonderful loose brushwork, warm, atmospheric colorism, brilliant armor, and dominating, idealized visage that imparts such authority.

During negotiations for the Rubens in 1897, Isabella Gardner acquired a portrait by the most talented and celebrated of Rubens's pupils, Anthony Van Dyck (1599–1641), through the agency of Berenson. Hanging opposite the Rubens, **A Lady with a Rose** is a beautiful example of Van Dyck's late style, in fine condition. On stylistic grounds, given its shimmering, silvery tonalities and informal grace, the painting is generally dated to the artist's last five years in England (1635–1640). The rose

the sitter holds is probably a reference to love or beauty. The painting conveys the elegance and status of the sitter, and in the lady's gentle smile, enlivened expression about the eyes (reminiscent of Rubens), and delicately painted scarf, hair, and hands, imparts a gentle intimacy.

On either side of the door between the Dutch Room and the corridor to the Tapestry Room hang pendant portraits of **Sir William Butts, M.D.,** and his wife, **Lady Butts,** by the most outstanding portraitist to work in England in the sixteenth century, Hans Holbein the Younger (1497–1543). Painted in the last year of Holbein's life, the portraits are the only surviving pair of a married couple by the artist, and the portrait of Lady Butts is Holbein's only single portrait of an older woman. Holbein combines a monumentality conveyed through the breadth and volume of the figures with an analytic observation of their faces. Sir William was a distinguished physician who was knighted in 1545. He served as personal physician to Henry VIII and Princess Mary, later Queen Mary, whose formal portrait, from the studio of Anthonis Mor (ca. 1517–1576/77), hangs nearby. Lady Margaret Butts was lady-in-waiting to Queen Catherine Howard. With a sense of whimsy, Isabella Gardner placed the two portraits on either side of a portal beneath an English needlework tapestry, **A Man and Woman in a Garden,** dating to about 1590–1610. The tapestry depicts a courting couple in a garden, surrounded by many animals, real and fantastic. This most secular of images hovers delightfully above its portal in marked contrast to the Bavarian

Peter Paul Rubens, *Thomas Howard, the Earl of Arundel*

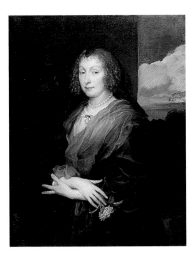

Anthony Van Dyck, *A Lady with a Rose*

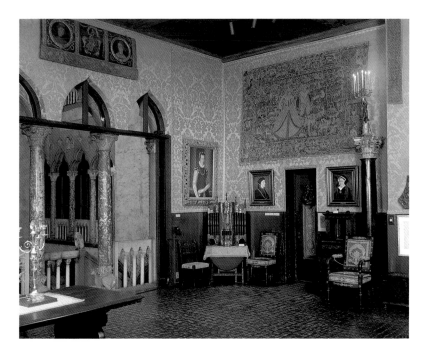

The Dutch Room, view toward the courtyard, with English needlework tapestry, *A Man and Woman in a Garden,* above the door, and Hans Holbein the Younger's pendant portraits, *Sir William Butts, M.D.,* and *Lady Butts,* framing the door

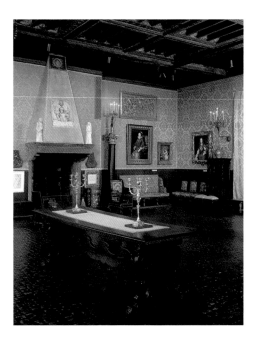

The Dutch Room, view toward the fireplace, with Studio of Antonis Mor, *Mary Tudor,* at right

polychrome wood relief of **Saint Martin and the Beggar,** created about 1520, that surmounts the doorway near the Rembrandt self-portrait.

In this room of portraits, interrelationships both subtle and obvious proliferate and must have delighted Isabella Stewart Gardner. Sir William Butts was physician to Mary Tudor, who was for a time married to Philip II of Spain, whose daughter by his subsequent marriage to Elizabeth of Valois was **Isabella Clara Eugenia, Archduchess of Austria,** depicted to the right of the door from the stairway hall in a formal presentation portrait of about 1598 by Frans Pourbus II (1569–1622). Sovereign of the Catholic Netherlands, the archduchess was a patron of Rubens, with whom she maintained warm personal relations. And Rubens in turn was the master of Van Dyck. It was, however, owing to the presence of the works of Rembrandt and Vermeer that Isabella Gardner named this room the Dutch Room.

Third-floor Rooms

On the third floor, along the wall above the stairway, hangs one of the earliest and most important of the nearly forty tapestries in the museum collection, **Amazons Preparing for a Joust,** a Franco-Flemish (then Burgundian) textile datable to about 1450–1475. Executed in wool and silk, this richly ornate tournament scene, which reflects the late Gothic interest in chivalric literature and the elegance of figures and brilliant fabrics of the International Gothic style, depicts Queen Orchia ordering her women to arm themselves. The two figures about to joust are Orchia's warrior daughter, Hippolyte, and her friend Menalippe, who later battled Hercules and Theseus.

To the right before one enters the next gallery is **A Lady in Black,** a portrait formerly attributed to the sixteenth-century Venetian master Jacopo Tintoretto (1518–1594) and by his son Domenico (1560–1635). The painting is based on portrait types Tintoretto explored in the 1560s and 1570s and is enlivened by an atmospheric landscape on the right. The portrait is more a glorification of wealth and station than a character study, its elegant subject the embodiment of self-assured splendor and grace. The artist focuses on the contrast between the decorative details of jewels, lace, and curtain and the roughly defined yet vividly lit landscape. The sitter remains a cipher, her personality as much as her identity a

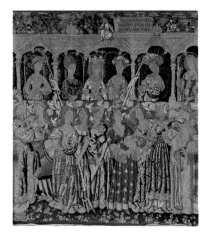

Flemish tapestry, *Amazons Preparing for a Joust,* detail

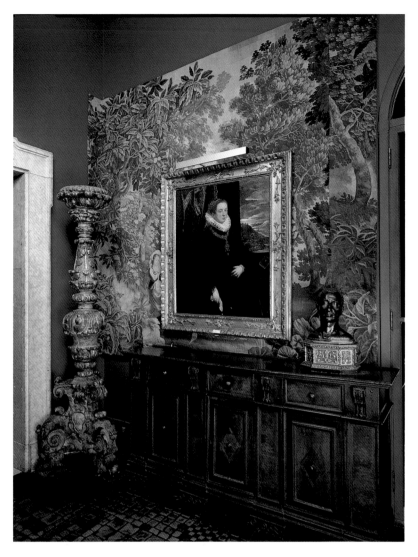

Domenico Tintoretto, *A Lady in Black,* in situ

mystery. Isabella Gardner acquired the portrait in 1903 from the collection of Prince Chigi in Rome at the suggestion of John Singer Sargent.

The Veronese Room

The Veronese Room, the first gallery on the third floor, is a dark yet sumptuous space created by an extraordinary wallcovering: gilt and painted Spanish (mostly) and Venetian leather of the seventeenth century. Gardner acquired the pieces between 1892 and 1901 in Germany

and Italy, and she enhanced the effect by placing gossamer lace curtains in the windows and a case of antique laces in the corner. The glistening space has the feel of a personal reception room, an antechamber that opens dramatically on the splendor of the grand *salone* that is the Titian Room.

The ceiling emulates Venetian painted and gilded ceilings of the late fifteenth and early sixteenth centuries and was commissioned to accommodate the ceiling decoration that gives the room its name: **The Coronation of Hebe,** executed by Paolo Veronese (1528–1588) and his studio in the 1580s. The work was painted for a ceiling at the Palazzo Della Torre in Udine, where it remained into the eighteenth century, when it was moved to Venice. At the center, Hebe is presented by Mercury to her parents, Jupiter and Juno, in the company of the Olympian deities, as she assumes her role of cup bearer to the gods. More than fifty figures fill the composition, in which the perspective is adjusted to be seen from a forty-five-degree angle as one walks through the room—a perspective system common in Venetian ceiling works. At Fenway Court this effect is achieved by looking up at the work from just beyond the doorway of the Titian Room. Richly attired forms convey little emotion but exultantly celebrate the realm of the senses. Venice, surrounded by water, was the most opulent city in sixteenth-century Europe, and Veronese's rich coloring and sensitive glazes evoke its moisture-laden atmosphere and give the work a sensuous, almost tactile quality.

On the wall to the left of the doorway is an oil sketch, **The Wedding of Frederick Barbarossa to Beatrice of Burgundy,** traditionally attributed to Giovanni Battista Tiepolo (1696–1770) and probably executed after his designs by his son Giovanni Domenico Tiepolo (1727–1804). Tiepolo, the outstanding figure in eighteenth-century Venetian painting and esteemed in his lifetime as Veronese reborn, was invited to Würzburg in 1750 by Prince Bishop Karl Philipp von Greiffenklau to decorate the prince's palace. Tiepolo's creations, arguably his decorative masterpieces, adorn the palace staircase and Kaisersaal and celebrate great moments in the history of Würzburg and the glory of the elector, according to a fixed program. The event depicted in the Gardner oil sketch took place in Würzburg in 1156, although the composition and sartorially splendid figures owe more to the age of Veronese and theatrical fantasies of the High Renaissance in Venice. Tiepolo remained in Würzburg from December 1750 through 1753, accompanied by his sons Giovanni Domenico and Lorenzo. Oil sketches served many purposes for Tiepolo, including presentation models, records of works, and independent presentation works. They even seem to have been created as *capricci,* free

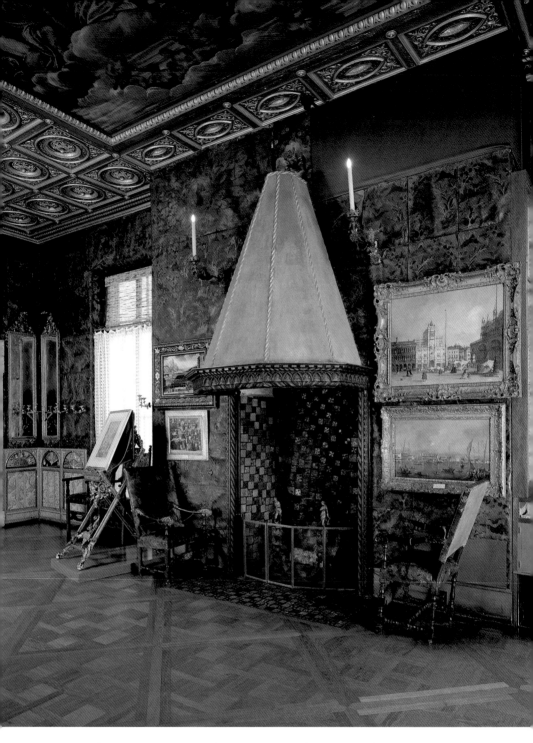

The Veronese Room, with Francesco Guardi's *View of the Riva degli Schiavoni and the Piazzetta from the Bacino di San Marco* to the right of the fireplace

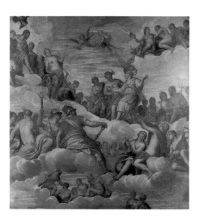

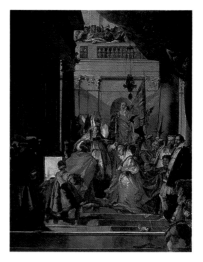

Paolo Veronese and Studio, *The Coronation of Hebe*

Giovanni Domenico Tiepolo, *The Wedding of Frederick Barbarossa to Beatrice of Burgundy*

interpretations of earlier designs and models. These could be executed by the master himself as well as by his sons or studio. The precise relation of this sketch to the fresco at Würzburg remains enigmatic.

The Veronese Room contains another notable eighteenth-century Venetian painting: **View of the Riva degli Schiavoni and the Piazzetta from the Bacino di San Marco,** by Francesco Guardi (1712–1793). The production of *vedute,* Venetian views for the tourist trade, became a major industry in the eighteenth century, and the two artists most commonly associated with this genre are Canaletto (Giovanni Antonio Canal, 1697–1768) and Francesco Guardi, who was Tiepolo's brother-in-law. Unlike Canaletto's meticulous, draftsmanlike records and caprices of Venetian architecture, Guardi's work stands in the deeper Venetian tradition of dreamlike, densely atmospheric, painterly evocations of his city. This emblematic view across the lagoon, with its limpid, almost washlike application of tonally sensitive brush strokes, captures the Piazzetta San Marco in the pallid atmospheric light of afternoon.

Returning to the Tiepolo oil sketch, beneath that painting are four pastels by James McNeill Whistler, including the earliest nonphotographic portrait of Isabella Gardner in the collection, **The Little Note in Yellow and Gold,** of October 1886. The small drawing conveys little more than the vivacity and alertness of its subject, but it is a finely

graduated study of yellows, golds, and whites. Something of Gardner's perspicacity and humor, suggested in this pastel by her smile and raised eyebrows, is evident in her installation of the portrait. Although she acquired two other Whistler pastels that year, **The Sweet Shop, Chelsea,** and **The Violet Note,** both of which hang nearby, the work she placed next to her portrait was yet another pastel by Whistler, acquired nine years later: **Lapis Lazuli,** a study of a reclining nude model in an open kimono.

On the north wall, over the eighteenth-century Venetian end table and the black glass Venetian Madonna altar figure of about 1600, designed to emulate venerated, darkened Byzantine figures, is an eighteenth-century portrait of a Venetian procurator, possibly a member of the distinguished Contarini family. The room thus resembles an eighteenth-century Venetian antechamber, or private *salone,* an effect Gardner heightened by the corner placement of her writing desk and a chair painted to imitate Chinese lacquer and ornamented in gilt in the eighteenth-century Italian Rococo taste for chinoiserie. The chair was devised from an eighteenth-

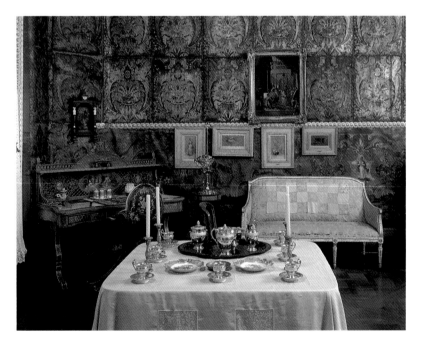

James McNeill Whistler, *The Little Note in Yellow and Gold, The Sweet Shop, Chelsea, The Violet Note,* and *Lapis Lazuli,* and Giovanni Domenico Tiepolo, *The Wedding of Frederick Barbarossa to Beatrice of Burgundy,* in situ

James McNeill Whistler, *The Little Note in Yellow and Gold*

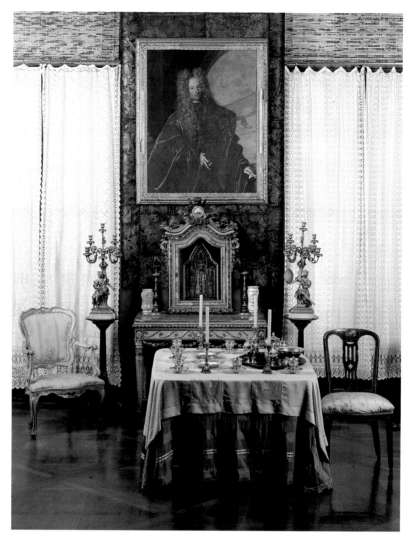

The Veronese Room, north wall, with the portrait of a Venetian procurator (above) and the black glass Madonna (below)

century Italian gig seat. A final personal touch is the early nineteenth-century gilt porcelain tea service placed on the table as though prepared for serving guests.

The Titian Room

Among the rooms, galleries, and passageways that constitute Fenway Court, no space better captures the grandeur of Isabella Gardner's vision, the subtlety of her eye, and the spirit of her Venetian summers spent in the

Rococo splendor of the Palazzo Barbaro than does the Titian Room. If the courtyard is the apotheosis of the *cortile* of that palace, where she studied Italian in the shimmering Venetian light, then the Titian Room is the evocation of its grand reception hall, its *salone*. If that room in Venice was the focus of Gardner's Venetian social life, where she surrounded herself with Henry James, Anders Zorn, Bernard Berenson, and the Infantas of Spain, here in Boston she convened another type of artistic constellation. Dominating the splendid Rococo-furnished gallery, with its works by Benvenuto Cellini and Diego Velázquez, is the treasure of her collection and the greatest Venetian painting in the United States, Titian's *Europa*. She surrounded the painting with Venetian furnishings and glassware opposite the marble entry portal at a height where the natural morning sunlight streaming in through the Venetian window casements would match the lighting within the painting.

Between 1554 and 1562, Titian (Tiziano Vecellio, ca. 1488–1576) embarked on a series of six paintings sent to Philip II of Spain. He termed the compositions *poesie*, poetic interpretations of themes of divine love from Greek mythology and Roman sources. The subjects were split between tragic and blissful topics and were chosen by Titian himself. **Europa**, executed in 1561–1562 and following a description of the myth in Ovid's *Metamorphoses*, draws the cycle to a raucous and joyful, even comic climax. Having appeared in many guises in his amorous pursuits, Jupiter decided to take the form of a white bull. Descending with an otherwise normal herd to a shore where the princess Europa and her handmaidens were bathing, he delighted them with his beauty, soft lowing, and gentle behavior until Europa climbed on his back. At that point he soared away with her over the sea, to the terror of the handmaidens and the princess, who held onto him by his horns. Traveling across the Mediterranean, she gave name to a continent. The pair arrived in Crete, where in a happy conclusion Europa gave birth to a line of wise kings.

Titian's depiction is extraordinary: rather than reconstructing antiquity, he revivifies it, creating a palpable atmosphere within which the sensuous, tactile forms emerge and dissolve. The composition is conceived in two great ovals. One moves across the picture plane, encompassing the *amorini* and scaly sea creatures across to the terrified figure of Europa, her pose echoed in the amor above her, and leading to the bovine glance of Jupiter out to the viewer. The second oval extends from the distant landscape past the handmaidens who race toward the shore and to the foreground figures. The Venetian school was renowned for its

Overleaf: The Titian Room

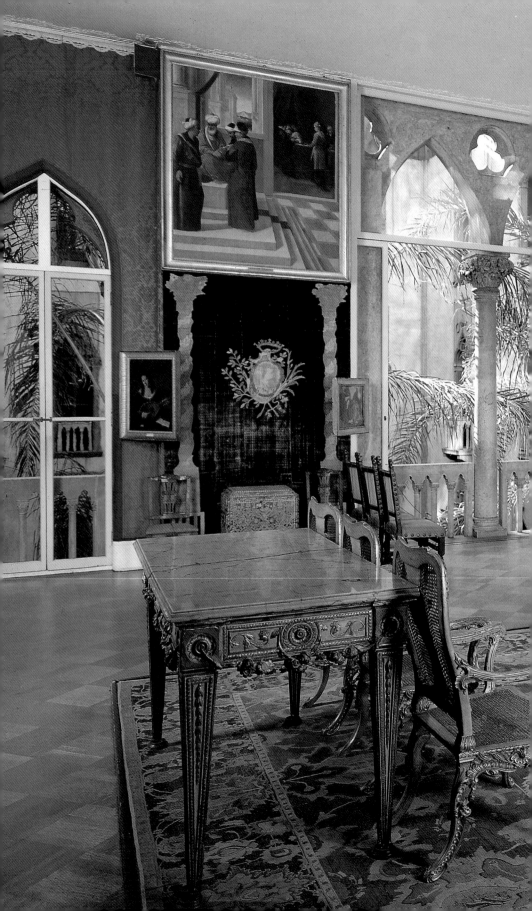

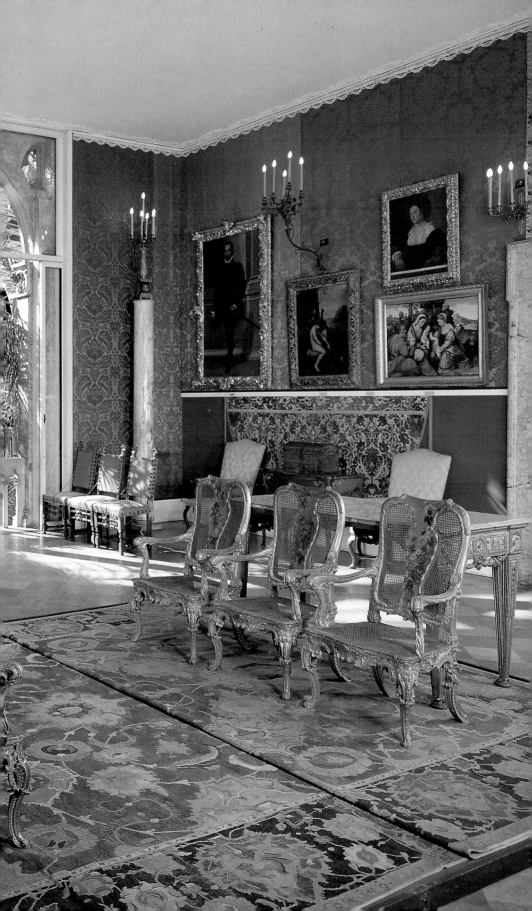

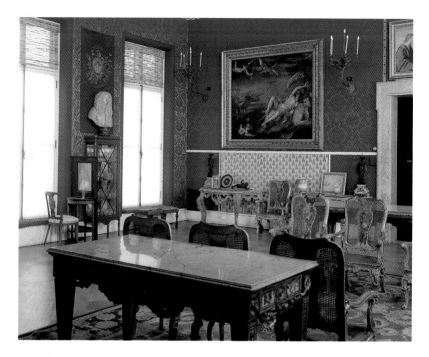

The Titian Room, view toward Titian's *Europa*

colorism, and Titian, who in his late works used immense brushes and even his fingers to obtain the vivid, fluid effects he sought, masterfully conveys through color the emotion that is at the heart of the painting. From the pearly opalescence of Europa's flesh, so softly and porously depicted, to the brilliant, shiny scales of the sea creatures beneath, the viewer is sensuously drawn into the subject. Even the rosy twilight land-scape evokes the passion of the moment. Other devices also draw the viewer into this visual poetry. The perspective has been shifted so that the water seems to splash up to the picture plane and out from the painting. The picture was intended to be seen often by its patron, and depending on the viewer's state of mind, it can be a ribald or a sublime affirmation of the miracle of love. Through Titian's eyes and hand, antiquity lives again, forever frozen in time yet eternally occurring.

Bernard Berenson, who had traveled to England in a unsuccessful attempt to acquire Thomas Gainsborough's *Blue Boy* for Isabella Gard-ner, acquired *Europa* from the sixth earl of Darnley, its ninth possessor, in June 1896. Gardner adored the painting and wrote to Berenson when it arrived, "I have no words! I feel 'all over in one spot,' as we say. I am too excited to talk," and several weeks later stated, "I am breathless about *the Europa*, even yet! I am back here tonight . . . after a two days'

orgy. The orgy was drinking my self drunk with *Europa* and then sitting for hours in my Italian Garden at Brookline, thinking and dreaming about her. Every inch of paint in the picture seems full of joy. . . . many painters have dropped before her. Many came with 'grave' doubts; many came to scoff; but all wallowed at her feet. One painter, a general skeptic, couldn't speak for the tears! all of joy!!! I think I shall call my Museum the Borgo Allegro. The very thought of it is such a joy. Mr. Hooper long ago, pleased me greatly by saying that I was the Boston end of the Arabian Nights. And now he only adds 'I told you so.' "

In Fenway Court, Gardner placed the Titian above two eighteenth-century Venetian end tables. On one is placed a **putto** attributed to François Duquesnoy (1597–1643), set on its side to mime the poses of Europa and the putti, its feet in front of an enamel platter, the design of which suggests the splash of water. A watercolor attributed to Van Dyck after a Rubens copy of the Titian *Europa* (that Rubens now at the Prado, Madrid) is adjacent. On the wall above the end tables Gardner placed a piece of silk taken from a gown designed for her by Worth of Paris, its color and tassel pattern complementing the tables. Completing the ap-

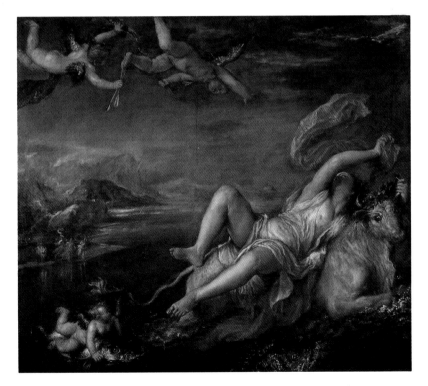

Titian, *Europa*

proach to the work is a mid-sixteenth-century Persian carpet, roughly contemporary with the painting, that dominates the room and picks up many colors found in the Titian. Gardner acquired the carpet at the suggestion of John Singer Sargent in London in 1894, two years before she purchased the painting.

On the opposite side of the portal is a life-size portrait by Velázquez of **Philip IV** of Spain. Grandson of Philip II and a great lover of art, Philip ascended to the throne in 1621. The Gardner portrait, which dates to the mid-1620s, is a replica of a version at the Prado. The head and hands are by the master himself, and the remainder was completed by his studio. The head is carefully posed to understate the Hapsburg monarch's severe lantern jaw. Presented in a simple, grand contour, the king wears the Order of the Golden Fleece and the simple pasteboard white-collar *golilla* that replaced ruffs (viewed as extravagant in that repressive era and abolished by law in 1623). Every pictorial device conveys regal authority: the low perspective that emphasizes Philip's height and dominance; the bare setting that isolates him; the single, stable central silhouette, its arching contour given uniformity and breadth by the long cape; and the restricted palette dominated by black. It is an ironic testament to a monarch who reigned during a period of Spanish decline. The Gardner painting, acquired in 1896, was created for the marquis of Leganés, cousin of Count Olivares, chief minister to the king, and concluded a remarkable year of acquisitions.

One of the most important portraits in the museum collection is a sculpture. The only monumental bronze in the United States by the Florentine Renaissance sculptor Benvenuto Cellini (1500–1571), **Bindo Altoviti**, executed about 1550, eschews allegory and mythic allusion despite its large scale and character as a classically inspired bust. In 1547, Cellini had completed a nearly double life-size bust of Duke Cosimo I de' Medici (Florence, Bargello). The Cosimo bust projects authority and power; the duke wears a cuirass that is boldly and intricately ornamented with grotesque heads, eagles, and a Medusa. The Altoviti bust, only two inches shorter than the Cosimo portrait, is of a different character altogether. The two busts may at first seem to be complementary images of king and philosopher types, but this is an oversimplification. Altoviti, a Roman banker born in 1491, was descended from a prominent Florentine family. He was one of the wealthiest men of his day, and his bank became the most powerful in Rome after the Chigi bank closed in 1528. Altoviti held republican sentiments and was hostile to the Medici dukedom, but he was so powerful that he was favored by Medici popes and even appointed consul and member of the Consiglio of Florence by Ales-

From left to right: Diego Velázquez, *Philip IV*, Benvenuto Cellini, *Bindo Altoviti*, and Baccio Bandinelli, *Self-Portrait*

sandro de' Medici. In 1546, Cosimo I appointed him a senator. Business being business, the duke was several thousand *scudi* in debt to Altoviti in spite of Altoviti's political beliefs. After he subsidized a failed coup in 1552, however, Altoviti lost all his Florentine properties to the dukedom.

Altoviti was portrayed as a young man by Raphael (ca. 1515, National Gallery of Art, Washington, D.C.) and was a friend of Michelangelo. Cellini must have received ducal permission to travel to Rome to execute Altoviti's portrait. The bust was a triumph. Cellini's idol, Michelangelo,

Benvenuto Cellini, *Bindo Altoviti*

called it beautiful in a letter to Cellini, complaining only that it was lit from beneath rather than from the opposite side from above. In his *Autobiography,* Cellini, an adventuresome and charming rogue who never suffered from false modesty or understatement, quotes Michelangelo's letter: "My dear Benvenuto, I have known you for many years as the greatest goldsmith of whom we have any information; and henceforward I shall know you for a sculptor of like quality."

The bust is in excellent condition, its detailing and chasing extraordinarily crisp, and it survives on its original base, which bears the Altoviti arms. The large, brooding figure turns slightly as though concentrating and wears a woven cotton cap into which his hair has been tucked and through which it is visible. Certainly the embroidered cap and simple shirt and cloak complemented Altoviti's republican sentiments. This contemporary image of Altoviti is the paragon of a Florentine republican and capitalist, a foil more than a complement to Cellini's portrayal of Cosimo I.

On the west wall are two paintings of note. Opposite the Velázquez is **Full-Length Portrait of a Bearded Man in Black,** dated 1576, a late work by the Brescian painter Giovanni Battista Moroni (ca. 1520–1578). The elegant composition and restrained palette of blacks, grays, and terracotta monumentalize the subject. Through scale and active pose, with his

left leg moving forward and his hand clutching the hilt of his sword, the man dominates the nearly abstract space, confronting the viewer with a stern expression. Moroni's portrait is clearly about the psychological and physical imposition of power. The subject does not reveal his personal self in any way and Moroni's emphasis on surface pattern depersonalizes him. His pose, sharply chiseled contours, expensive but somber, Spanish-style attire and frill collar, and cold stare indicate his social and economic station—the true subject of the portrait. This aesthetic of elegance and psychological distancing associates the painting with the central Italian style known as Mannerism, whereas the veristic detailing and fluid handling of blacks and flesh tones relate it to the art of Lombardy and Venice.

Isabella Gardner placed yet another important Venetian painting of the sixteenth century opposite the Titian: **The Child Jesus Disputing in the Temple,** by Paris Bordone (ca. 1500–1571). The painting, executed in brilliant acid colors, is composed in a sweeping diagonal and set within a chamber that resembles the meeting room of a Venetian *scuola,* or confraternity. The complex rhythmic patterning of flooring, architecture, sculptures, books, torn sheets, scrolls, figures, colors, and perspective date the painting as a mature work by the artist, executed in the mid-1540s. Michelangelesque anatomies, dynamic shifts in scale, telescoped

Giovanni Battista Moroni,
*Full-Length Portrait of a Bearded
Man in Black*

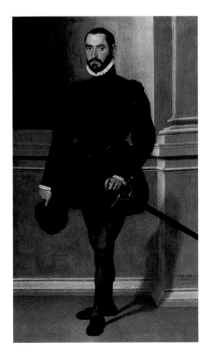

space, and operatic gestures focus the beholder's attention on critical figures. Color and theatrical spotlighting draw the eye to the figure of Christ, who is interpreting Scripture and disputing with the doctors in the Temple, as well as to the Virgin, who enters from the right with a gesture that complements her son's movements. The richly detailed picture epitomizes painting in Venice at mid-century.

The Titian Room contains the most opulent statements of the golden age of Venetian art at Fenway Court, but it also contains its most inti-

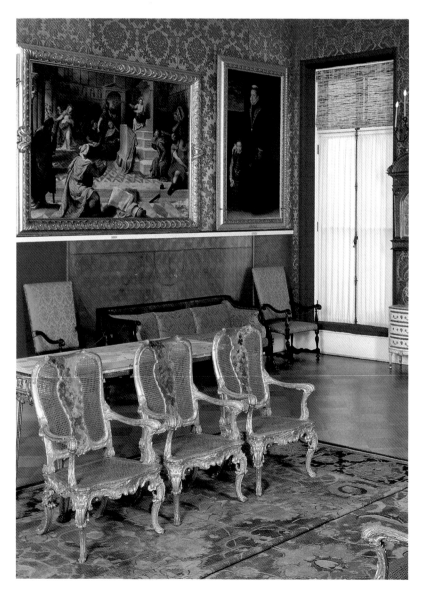

Paris Bordone, *The Child Jesus Disputing in the Temple*, in situ

Workshop of Giovanni Bellini, *Christ Carrying the Cross*

mate expression: **Christ Carrying the Cross,** created in the workshop of
Giovanni Bellini about 1505. This work clearly held special meaning for
Gardner, and she determined to purchase the painting, then attributed to
Titian's master and Venice's first great High Renaissance painter, Gior-
gione, in September 1896 (Berenson wrote her, "So you want the Loschi
Giorgione. Well, you shall have it, if it is to be had. . . . Yet, it somehow is
not the kind of thing I think of for you"). The painting arrived in late
1898, shortly before her husband suddenly died. In front of it she set a
Norwegian silver cup in which she placed violets when in season. Both
the cup and violets carried associations of her husband. Jack Gardner

had bought her violets on a trip to Rome, and she had placed a cross of violets on his coffin. Years later she requested that violets, if in season, be placed on her own coffin. The museum has returned to the custom of placing freshly cut flowers—violets or similarly colored blossoms—in the cup.

Christ Carrying the Cross is a lucid, vivid stimulus to meditation. The beholder of a religious image in early sixteenth-century Venice was prepared to a much greater degree than is the modern viewer to enter into the unfolding drama, to employ the image as a vehicle toward interior visualization. This is the appropriate context for understanding *Christ Carrying the Cross*. The painting is conceived as a narrow sculptural relief, and the figure of Christ stares outward, sharing his agony with the viewer, who is expected to feel a powerful religious empathy. The lack of any painted context allows the viewer's imagination to place the event anywhere. In its sensitivity to soft modeling and its atmospheric shading the painting is distinctively Venetian, and its evocation of the tactile surfaces—flesh and tears—enhances the spiritual impact.

The Long Gallery and Chapel

From the Titian Room one enters the Long Gallery, a corridor that culminates in the Chapel. To the immediate right, over a fifteenth-century Tuscan credenza is the earliest Botticelli in the museum collection, the lyrical **Madonna of the Eucharist,** datable to the early 1470s, when the young artist was still under the influence of his master, Filippo Lippi. Gardner acquired the painting from the Roman collection of the Princes Chigi, but not without controversy and even litigation. In 1898, Isabella Gardner was informed that Prince Chigi might sell the work—against the restrictions of new Italian laws—and he then did sell it to the dealer Edmond Despretz, for the London dealers P. & D. Colnaghi. After Isabella Gardner saw the painting in London, she pressed Berenson to acquire it for her. Though Berenson was not particularly keen on the work, it became one of the treasures of her collection. The story did not end there, however. The Italian government fined Prince Chigi for the price of the sale, and Isabella Gardner, in order to establish both the Botticelli's authenticity and her ownership of it, was required to exhibit the work in London in 1901 before it could be shipped to her. The work received universal acclaim. As the *Times* of London noted, the painting belongs "in the small front rank of the master's easel pictures . . . of quite remarkable design and expression; the child's attitude is wonderful and Botticelli never painted a lovelier head than that of the young attendant."

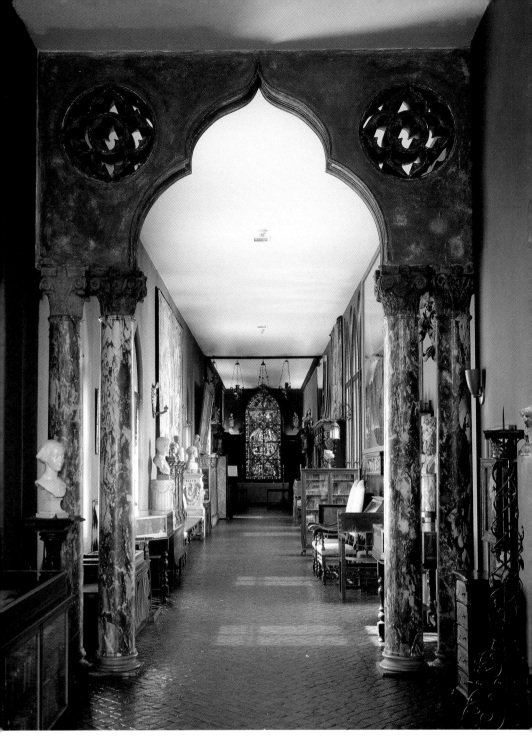

The Long Gallery

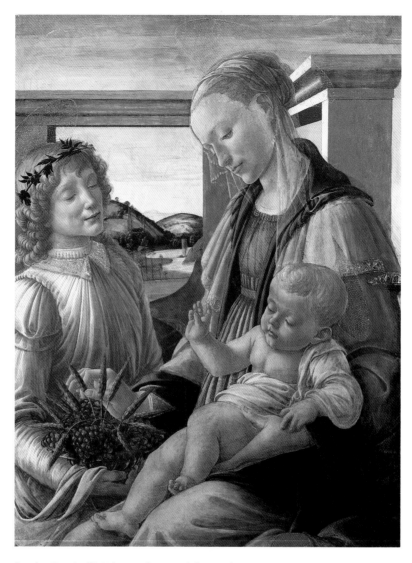

Sandro Botticelli, *The Madonna of the Eucharist*

As for the prince, being the descendant of a venerable family that produced two popes and numerous cardinals had its privileges: his fine was reduced from 20,000 to 80 lire.

The painting depicts the Madonna and Child in front of a lovely landscape with a meandering stream. An angel presents them with grain and grapes (the bread and wine of the Eucharist), and the Child makes the sign of the benediction while his mother gently contemplates the significance of these symbols of the Passion. The work is notable for its Neoplatonic idealization of the figures to convey the purity and beauty of

their souls, yet each figure is individualized in feature and character. Gardner clearly appreciated the painting's luminous colorism, placing in front of the work a fragment of a mid-fourteenth-century glass mosque lamp whose enameled colors and gilt correspond to those in the Botticelli.

On the left as one proceeds toward the Chapel is the large (nearly 100 inches high and sixty-three inches wide) glazed polychrome terracotta **Lamentation over the Dead Christ,** by Giovanni della Robbia (1469–1529), dating to about 1515–1520. Giovanni was the second son of

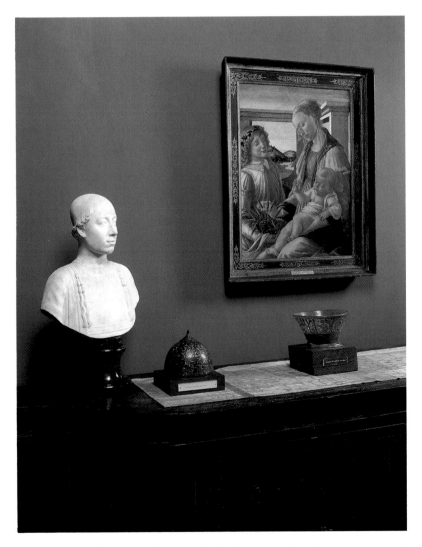

Sandro Botticelli, *The Madonna of the Eucharist,* in situ, above a fragment of a mosque lamp

Andrea della Robbia, whose uncle Luca had perfected and popularized the ceramic technique. The family's large studio made multiple reproductions of molds of varying quality. In Giovanni's work the restrained, harmonious compositions and palette of his father's work (evident in the nearby late fifteenth-century **Tabernacle with Angels** from Andrea's workshop) are transformed by a more brilliant, even garish palette and a more obvious appeal to sentiment. The dead Christ hovers outward into the viewer's space, and a Latin inscription from Jeremiah, below, reads, "Oh all you that pass by, behold and see if there be any sorrow like unto my sorrow." Behind the cross to the left is a landscape with Calvary in the distance and to the right the angel and the three Marys at Christ's tomb. At either side of the cross angels hold the kerchief of Veronica, while the crown of thorns encircles the cross like a victory crown. The frame is composed of tiles bearing the conventional floral motifs for which the della Robbias were famous.

Throughout the gallery and beneath Roman sculptural fragments and busts are cases filled with rare books Isabella Gardner purchased between 1886 and 1924, many acquired before she focused on the fine arts. The printed books include ten fifteenth-century and seventy-four sixteenth-century works. Although Charles Eliot Norton advised Gardner in the art of book collecting, in typical fashion she followed her own inclinations. She amassed more than one thousand rare books and manuscripts—and catalogued them herself in a book she had privately printed in 1906. Among them are many early Venetian texts and historic editions of Dante, including a rare and beautiful **Divine Comedy** printed in Florence in 1481 and illustrated with engravings after drawings by Botticelli for the *Inferno*. The Gardner copy is noteworthy as one of the few surviving copies to have all nineteen illustrations intact.

Giuliano da Rimini is hardly a household name, yet his large altarpiece of **The Madonna and Child Enthroned, with Saints Francis, John the**

Giovanni della Robbia, *Lamentation over the Dead Christ,* detail

The Long Gallery, view to the north, with bookcase and Roman busts

Dante Alighieri, *The Divine Comedy* (Brescian edition, 1487), with Rivière binding

Engraving illustrating the seventh canto of Dante's *Divine Comedy*, after a design by Sandro Botticelli (Florence, 1481)

Baptist, John the Evangelist, Mary Magdalene, Clare, Catherine, Agnes, Lucy, and Donors, over the fifteenth-century choir stalls on the left side of the hallway approaching the Chapel, is among the most interesting pieces in the museum collection, for the painting presents the transition from the Italian Romanesque to the Gothic style—the process of the "rebirth" of Italian art, as Giorgio Vasari thought of it from the vantage point of sixteenth-century Florence. The altarpiece is inspired by Giuliano's contemporary Giotto (see the discussion of Giotto's work in the Gothic Room). At its center appear the Madonna and Child surrounded by the nuns of the Franciscan Order of Saint Clare and the patrons who commissioned the work. The relative size of the figures is determined by their theological significance. The infant Christ, holding decretals, wearing imperial purple, and being held in his enthroned mother's hands, resembles a small "man-emperor." Various saints of intermediate scale are depicted in a subsidiary double-storied arcade, including Saint Francis in the upper left corner, clearly based on the Giottesque figure in a fresco painted about 1300 for the Upper Church at Assisi. Also bearing Giotto's influence is Giuliano's attempt to give his figures weight and volume through a consistent light source that casts shadows. The artist was obviously proud of his achievement, for, in an unusual act for this date, he signed the work in Latin across the upper margin, "In the year of our Lord one thousand three hundred and seven Giuliano painter of Rimini made this work in the time of Pope Clement the Fifth."

Opposite the large altarpiece is a small oil painting of **The Wedding**

Feast at Cana, by Tintoretto. In its rapid, loose brush stroke, immature figure drawing, and restless rhythm the picture is indicative of Tintoretto's early style. The elongating, elegant aesthetic of central Italian Mannerism conjoins a native Venetian brilliance of color and dramatic foreshortening. The work is datable to the mid-1540s.

At the far end of the Long Gallery is the Chapel, where a requiem Episcopal Mass is held each year on Isabella Gardner's birthday (April 14), as stipulated in her will. Over the altar is set a remarkable example of French High Gothic stained glass, a twelve-foot window fragment from the cathedral at Soissons, datable to about 1205. The window was removed from Soissons when several chapel windows were dismounted for care in 1882. Shortly thereafter some of these narrative windows appeared in Paris. The historian Henry Adams, directed Gardner's attentions to the work and recommended that she acquire it. The window, created to honor Bishop Nevelon of Soissons on his return from the Fourth Crusade, incorporates stories from the legends of two obscure siblings, **Saints Nicasius and Eutropia,** who offered themselves as martyrs during the Vandals' attack on ancient Reims. The window fragment, most of which is original, is part of a much larger choir window, sections of which are at the Louvre. Some pieces were carefully inserted at later dates to replace fragments, and the scenes are no longer in their original sequence.

Giuliano da Rimini, *Madonna and Child Enthroned, with Saints Francis, John the Baptist, John the Evangelist, Mary Magdalene, Clare, Catherine, Agnes, Lucy, and Donors,* detail

Jacopo Tintoretto, *The Wedding Feast at Cana*

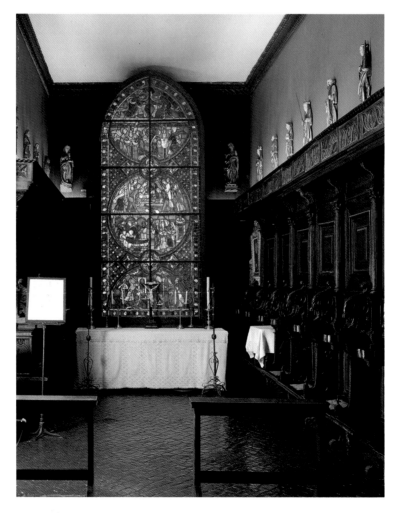

The Chapel, with the Soissons window

The final gallery of the Gardner Museum, the Gothic Room, is in some ways the inner sanctum of Fenway Court. It was off-limits to the visiting public during Isabella Gardner's lifetime. But Gardner put as much effort into the detailing of the Gothic Room as she did in any other gallery. She insisted that the large beams that transverse the ceiling be hewn by hand, selecting a workman from a Boston shipbuilding firm to create them. When the result seemed too planed, she took the broadax herself and hewed a beam more crudely for the workman to follow her lead. Above the paneling, near the ceiling, she installed a frieze of sixty-eight small paintings, fifteenth-century Italian portrait heads, that she acquired in Venice in 1888 and 1899. Though the space was closed to the public, Gardner did use the room for selected guests. In the spring of 1903 she offered the Gothic Room as a studio to John Singer Sargent during his visit to Boston, and he painted his portrait of *Mrs. Fiske Warren and Her Daughter* (now at the Museum of Fine Arts) in the room.

The gallery is entered from the Chapel and the third-floor passage, with its fine seventeenth-century Japanese screens, including the masterful pair illustrating episodes from *The Tale of Genji,* through a French Gothic carved oak tambour, or indoor porch, dating from about 1500. On the canopy to the fireplace hangs the coat of arms, in iron, of Isabella of Spain (1451–1504); the fireplace is Venetian and probably dates to the fifteenth century. In front of the fireplace Gardner placed two immense gilded-iron French Gothic torchères, each thirteen feet tall. Six stained glass windows are placed in the windows on the south wall. The two upper ones, made in Nuremberg in the 1490s, depict the donor, Lienhart Joechl, with his two sons and patron saint, Andrew, as well as his two wives (the first, who had died, in white) with Saint Peter. The lower windows are Flemish or German of about the same period or slightly later. Between these windows is set a large Spanish wheel-window that dates to the thirteenth or fourteenth century. This window was originally open, admitting light and air.

On the wall opposite the window, a magnificent German (Franconian or Saxon) late Gothic carved and gilded wood triptych, an altarpiece with central panel and two folding side panels, surmounts a French credence of about 1500. The altar-shrine, which probably dates to about 1510–1520, depicts **The Holy Kinship.** At its center are shown Saint Anne and her extended family, including Mary and the infant Christ,

Overleaf: The Gothic Room

John Singer Sargent painting *Mrs. Fiske Warren and Her Daughter* in the Gothic Room, 1903

who is shown receiving symbolic gifts of an apple and grapes. Wing panels feature Saints Catherine and Margaret on the left and Barbara and Dorothea on the right. Four male saints, not visible, are painted on the reverse of the side panels.

On the west wall, near the doorway, stands the figure of **Saint Elizabeth of Hungary,** dating to about 1490 from the upper Rhine or Swabia and crafted of linden wood. The nearly life-size, sorrowful figure, in nun's attire, is carved with great attention to the voluminous folds and pleats of her drapery. Although the surface has great rhythm, there is little sense of the saint's mass or weight, despite her bent right knee,

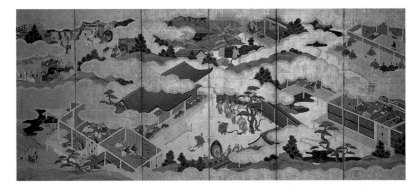

One of two screens by Fujiwara Tsunenobu illustrating *The Tale of Genji.*
Photo: Clive Russ

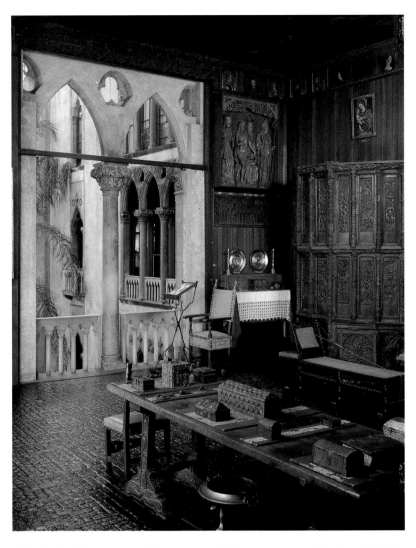

The Gothic Room, view of the courtyard-side east corner, with French Gothic tambour (right)

which presses to the surface of her robe. The whole forms a dynamic pattern around the simplicity of her face. Saint Elizabeth was a widowed queen who was deposed in 1231. She joined a monastic order and devoted her efforts to the sick and poor. She holds a loaf of bread in one hand and originally held a jug in her other hand.

Just beyond the portal, in the hallway, above and to the right, is a moving, rare twelfth-century Catalan **Christ** from a deposition group in polychrome rosewood. The nearly life-size figure of the crucified Christ

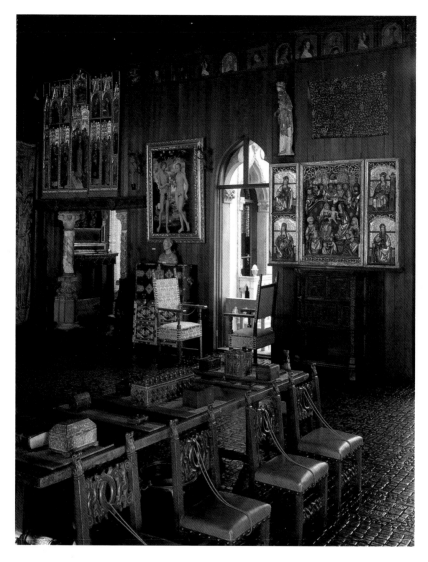

The Gothic Room, view of the courtyard-side west corner, with sixteenth-century German altar-shrine *The Holy Kinship* (right)

was originally the central figure of a group illustrating the Passion—the body would have been supported by figures of Nicodemus and Joseph of Arimathea. The artist has minimized details to emphasize with a few extended incisions in the sunken chest and attenuated limbs the suffering of his subject, the limp weight of the dead body, and the noble serenity of the softly modeled face. Beginning in the eleventh century believers began to enact the Easter liturgy in dramatic tableaux vivants as a way to experience and empathize with the Passion. This figure probably formed

part of a liturgical sculptural group that paralleled such activities. Its direct, theatrical appeal would have been heightened by paint, traces of which survive on the figure of Christ. Art created for this type of religious re-creation persisted in Europe well into the Baroque era.

Three paintings are the clear highlights of the Gothic Room. Two display a fascinating contrast in Italian Gothic styles, while the third, the great iconic image of Isabella Gardner, dominates the room and was why the Gothic Room was closed to the public during Gardner's lifetime.

On a stand by the west window, placed back to back, are two of Gardner's most important early Italian acquisitions. On the side facing the doorway is the altar panel of **The Presentation of the Infant Jesus in the Temple,** by the outstanding artistic genius of fourteenth-century Italy, Giotto di Bondone of Florence (probably 1267–1337). The distinguishing, pioneering characteristics of Giotto's achievement are immediately evident in this mature work, datable to the 1320s. The panel, which is of the highest quality and in a fine state of preservation, is one of seven surviving dismantled works from a single altarpiece in collections around the world. Giotto is generally agreed not only to have been the guiding hand in the composition but to have executed the painting himself. The subject, described in Luke 2:27–38, shows the Holy Family presenting the infant Christ in the temple. Jesus is being handed to Simeon, who had waited in Jerusalem for the coming of God's anointed, while to the right is Anna, who prophesied Christ as the redemption of Jerusalem.

Although the composition follows a convention found in late thirteenth-century Roman mosaics, Giotto brings a pioneering investigation of the

Upper Rhine or Swabia,
Saint Elizabeth of Hungary

Catalan *Christ* from a
deposition group

Giotto, *The Presentation of the Infant Jesus in the Temple*

human dimension, in the spirit of the gospel of Luke, to his depiction. This painting is far removed from the imperial Christ Child and hierarchical presentation of characters in the altarpiece by Giuliano da Rimini in the Long Gallery, even though that altarpiece was painted less than a generation earlier by an artist already responding to the younger artist's innovations. Giotto has attempted to probe the human nature of his subjects, seeking to bring the events of the Gospel to believers with immediacy and historical conviction, in the manner of contemporary Franciscan preachers. The Christ Child is truly an infant, pudgy, reaching out to his mother from Simeon's strange, wrapped hands (which allude to Christ's holiness), balancing himself charmingly by holding the beard of the aged man. Anna, too, is elderly. Painted in a haunting yellow-green, she seems an almost spiritual presence. Although the mathematics of perspective had not yet been discovered, Giotto dramatically foreshortens the tabernacle and lays out a convincingly three-dimensional patterned floor and solidly massed figures against the flattening gold background, a tremendous technical accomplishment. Giotto's painting conveys more mass, space, and depth than even *The Child Jesus Disputing in the Temple,* by the Sienese painter Giovanni di Paolo, datable to a century and a half later (in the Early Italian Room).

When Berenson wrote Isabella Gardner in 1900 that he could obtain the Giotto from the collector Jean Paul Richter in London, she wrote back excitedly and with a connoisseur's subtlety, "How I wish I had got your cable about the Giotto before that about the Rembrandt. Of course I want the Giotto–*that* there is no question about! But the Rembrandt left me cold, and it was only because you seemed so anxious about it, that I wired to get it. . . . I shall wire today, . . . 'Rather Giotto than Rembrandt.'" The Rembrandt she mentioned is **Landscape with an Obelisk,** in the Dutch Room (stolen in 1990), now recognized as a work by Rembrandt's student Govaert Flinck (1615–1660).

Gardner placed the Giotto *Presentation* panel on an easel opposite a beautiful work of the Sienese school. The **Madonna and Child** is a tender, intimate meditational panel traditionally attributed to Lippo Memmi (active 1317–died 1357), but recently properly reattributed to Memmi's brother-in-law, Simone Martini (1283/85–1344), in whose workshop Memmi worked. Simone, whose large altarpiece is in the Early Italian Room, was in a real sense Giotto's Sienese counterpart. This small portable altar (about thirteen by ten inches) depicts the Madonna and infant Christ above the figures of Saints Helen, Paul, Dominic (at center), Stephen, and the donor, a penitent Dominican nun. There is no evidence that the panel was ever attached to another panel. Simone has focused

John Singer Sargent, *Isabella Stewart Gardner,* and Giotto, *The Presentation of the Infant Jesus in the Temple,* in situ

attention on the jewel-like pouncing of ornamentation that adorns the figures, their halos, the engaged frame, and even the reverse. The Madonna, shown as queen of heaven, her complexion softly blushing, is draped in a deep blue mantle over a burgundy red gown, and Simone has painstakingly articulated the gold hem of the fabric. The infant Christ, depicted delicately, swathed in light gold-trimmed fabrics, rests tenderly in his mother's arms as both figures look toward the beholder from behind the frame. The viewer's eye runs along the fluid outline of the figures and focuses in contemplation on their faces. The contrast between these spiritualized, weightless forms of tender emotional intensity and the weighty and realistic figures of Giotto could not be greater.

Appropriately, the monumental iconic image of **Isabella Stewart Gardner,** which dominates this room of sacred art, completes the survey of galleries. This was the first of many works by Sargent she acquired. In October 1886, Henry James took Gardner to Sargent's studio in London, where Sargent had recently moved following the scandal in Paris over *Madame X,* his portrait of Mme Gautreau (see commentary on the oil sketch in the Blue Room). That portrait, refused by its subject, was in Sargent's studio, and on the basis of that work and others, Gardner

commissioned her portrait. The work was executed in Boston between September 1887 and February 1888—Gardner was forty-seven, and it was long before she envisioned Fenway Court.

The painting presents her as a pagan deity, as the contemporary press noted (Henry James characterized the picture as a "Byzantine Madonna"), with her head surrounded by a mandorla created from an enlarged version of Renaissance fabric now in the Long Gallery. She is simply presented in a black dress, and Sargent accentuated the features for which she was known—her fine complexion and her figure—by

Simone Martini, *Madonna and Child*

John Singer Sargent, *Isabella Stewart Gardner*

placing her flesh in relief to the darkness and tying a black shawl tight about her hips. Her pearls and rubies highlight the portrait (one critic called the rubies on her slippers "drops of blood"). Gardner confronts the spectator directly, uncompromising, as if assessing the beholder, and Sargent has animated her—and softened her features—by opening her lips as though she were about to speak. He reworked the portrait eight times, but the ninth essay was a success; she was delighted. When the new portrait was exhibited as *Woman—An Enigma*, at the St. Botolph Club in Boston, however, Gardner's décolletage and idol-like presentation, as well as her suggestive pose (actually a standard model's pose) and ostentatiously placed jewelry, sparked controversy. The negative comments so upset Jack Gardner that he asked that the portrait not be exhibited publicly during his lifetime. Accordingly, Isabella Gardner directed that the Gothic Room remain closed to the public until after her death. This portrait, far more than any reading of her biography, presages the accomplishments she was to make and her indomitable yet perceptive spirit.

We share Isabella Stewart Gardner's sense of wonder, universality of interests, and intoxication with beauty as we walk through the Gardner Museum today, and she lives through our curiosity, surprise, and appreciation. The words James Loeb wrote to her in April 1903 seem even truer as the Gardner Museum approaches its second century:

Sometimes I fear I share the so easily adopted view that life has become sordid and ugly in this new century of ours, but when I saw, as I did yesterday, that there still live those, who like you, need but to stretch out their hand and say

Quod erat, erit,

Quod fuit, sit!

I awoke to the cheering knowledge that it is as true today as it ever was that "he who seeks shall find" beauty.